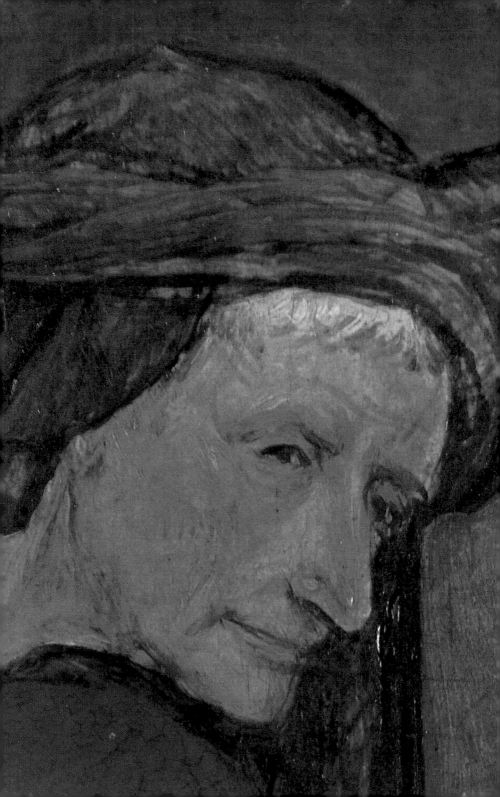

ArtBook
Bosch

DORLING KINDERSLEY
London • New York • Sydney • Moscow
Visit us on the World Wide Web at http://www.dk.com

Contents

How to use this book

This series presents both the life and works of each artist within the cultural, social, and political context of their time. To make the books easy to consult, they are divided into three areas which are identifiable by side bands of different colors: yellow for the pages devoted to the life and works of the artist, light blue for the historical and cultural background, and pink for the analysis of major works. Each spread focuses on a specific theme, with an introductory text and several annotated illustrations. The index section is also illustrated and gives background information on key figures and the location of the artist's works.

1452-1490

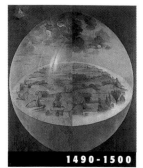

1490-1500

8 ■ Family workshop
10 ■ The Low Countries and the fear of flooding
12 ■ Flemish painting in the late fifteenth century
14 ■ Bosch in documents: an uneventful, quiet life
16 ■ The Cure of Folly
18 ■ Proverbs, folk culture, and the dawning of humanism
20 ■ Religious devotion and the "Imitation of Christ"
22 ■ The Conjurer

26 ■ Bosch's culture and religion: theories and contradictions
28 ■ End-of-century anxieties, sects, and dissent
30 ■ The Hay Wain
32 ■ The Hay Wain left panel
34 ■ Hell and Paradise: The architecture of fantasy
36 ■ Journeys into the unknown
38 ■ Ecce Homo
40 ■ A satirical best-seller: *The Ship of Fools*
42 ■ Death of the miser
44 ■ Local employment and foreign commissions
46 ■ The Garden of Delights
48 ■ The Creation of Eve
50 ■ Musicians' Hell
52 ■ Witchcraft in ancient sources
54 ■ Bosch's bestiary: zoology and fantasy

■ p. 2: Bosch, *Presumed Self-portrait*, 1505–6, Museu Nacional de Arte Antigo, Lisbon.

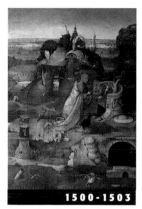
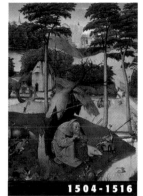

1500-1503

58 Bosch in Milan?
A controversial fresco
60 Leonardo and the
image of nature
62 Grotesque monsters
64 Ascent to Calvary
66 Bosch in Venice
68 The Crucifixion of
St Julia
70 Bosch and early
sixteenth-century
Venetian painting
72 "Northern" Venice
74 Bosch and Dürer:
a possible encounter
76 St John the Baptist
in the Wilderness
78 Expanding landscape
80 Preachers, mystics,
and visionaries
82 St Jerome
at Prayer
84 From Medieval
autumn to
Renaissance spring
86 Paradise and Hell

1504-1516

90 Bosch, Erasmus of
Rotterdam, and madness
92 Alchemy:
metamorphosis
of matter
94 Followers, imitators,
and copyists
96 The Last Judgment:
Medieval
to Renaissance
98 The Last Judgment
100 Artistic developments in
Holland and Flanders
102 Reality and fantasy: Art in
the Low Countries
104 Half-length paintings
106 Christ Crowned with Thorns
108 Destruction by fire
110 Temptation: a
timeless theme
112 Temptation of St Anthony
114 Flight and Fall
of St Anthony
116 Meditation of St Anthony
118 Winds of reform
120 The last works
122 Adoration of the Magi
124 The Epiphany triptych
126 Reflections on
human destiny
128 Bosch and engraving
130 The greatest interpreter:
Peter Bruegel
the Elder
132 Bosch and modern
culture: the unconscious
and the surreal

Index

136 Index of places
138 Index of people

Vice, eccentricity, and madness

Family workshop

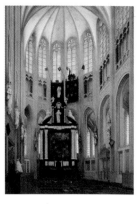

Jeroen Anthoniszoon van Aken was the real name of Hieronymus Bosch, one of the most enigmatic artists in the entire Western tradition, who chose to sign his own works with the name of his birthplace, 's Hertogenbosch, better known as Den Bosch. The painter was born in this bustling town in about 1450. Not far from the present Belgian border, Den Bosch was part of the duchy of Brabant, at the time in the possession of the dukes of Burgundy. The van Akens, originally from Aquisgrana, had long been dedicated to artistic activity. Bosch's paternal grandfather Jan was a painter, as was his father Anthonis (Antonius) and three of his four uncles. After Anthonis' death, Bosch's brother Goossen inherited his workshop. Although little is known of Bosch's early upbringing, it is safe to assume that he learned the rudiments of his trade, guided perhaps by his father or an uncle, in the family workshop. They specialized in fresco painting, the gilding of wooden statues, and the production of sacred hangings for the town cathedral. His pseudonym arose from a wish to distinguish himself from the rest of his family, which was a frequent custom in the Low Countries.

■ P.J. Saenredam, *The Cathedral of St John at 's-Hertogenbosch*, 1646, National Gallery of Art, Washington. This 17th-century painting shows the ancient appearance of the cathedral of 's Hertogenbosch, one of the most important Dutch Gothic monuments.

■ Bosch, *Crucifixion*, details, 1480–85, Musées Royaux des Beaux-Arts, Brussels. The turreted city below is identifiable as the birthplace of Bosch.

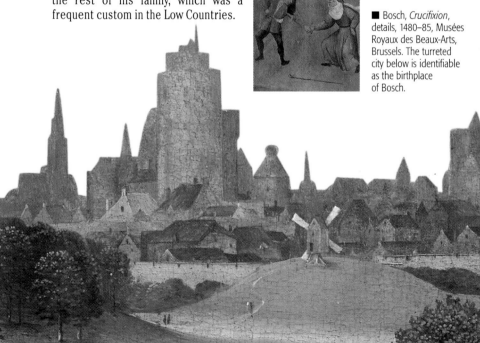

■ Bosch, *The Epiphany,*
1480–85, Museum of
Art, Philadelphia. A
work from his juvenile
period, this reveals the
influence of late Gothic
painting, both in the
development of line
and in the traditional
structure of the
composition, in which
the application of the
rules of perspective
still appears uncertain.

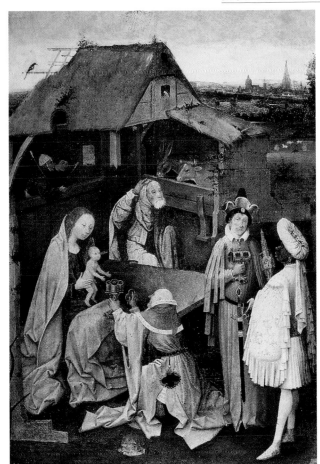

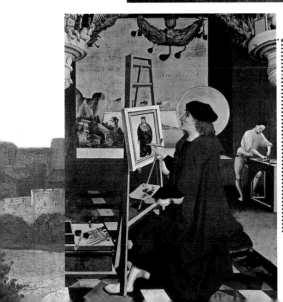

Apprentices and assistants

This painting by Nikolaus Manuel
Deutsch (c.1520, Kunstmuseum,
Berne), depicts the workshop of a
15th-century painter. The master
is seated at an easel, pallette in
hand, and the brushes are neatly
laid out on a small table; in the
background a boy prepares the
colors. This role was often
entrusted to the youngest in the
family, and Bosch's introduction to
the family workshop must have
been similar to this.

The Low Countries and the fear of flooding

The town where Bosch was born is today in Holland, but at that time there was no administrative division with modern Belgium: from 1426 the whole territory had been granted to the duchy of Burgundy. Nevertheless, there were marked differences between the landscape and topography of the two areas. The wealthy cities of Flanders such as Bruges, Ghent, and Antwerp provided a contrast to the northern provinces of the Low Countries, which were under the constant threat of flooding. The fight against the sea and the immense efforts required to control the discharge of the rivers had a determinant effect upon Holland's landscape and history: in the country areas, dotted with the unmistakable windmills, there stretched a network of canals, and already in the 13th century, engineers were constructing the first dikes as barricades against the North Sea's regular and destructive advances. People remembered the dreadful night of November 18, 1421, when the Rhine delta flooded sweeping away 35 villages and causing the deaths of some 100,000 inhabitants. Such events explain why in Dutch culture and art the fury of unpredictable and threatening waters is interpreted as a divine scourge, an overwhelming punishment for a faithless population.

■ Joachim Patinir, *The World of the Dead*, c.1520, Museo del Prado, Madrid. This magical landscape by one of Bosch's direct followers shows the boat of Charon crossing the expanse of water that separates the land of the living and the dead. Water is the vital resource of Dutch agriculture, but also marks the boundary of life and death.

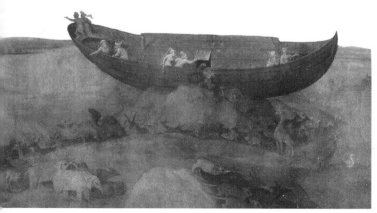

■ Bosch, *Triptych of the Flood*, detail of the *World after the Flood*, c.1500, Boymans-Van Beuningen Museum, Rotterdam. The panels, though not in a good state of preservation, show how even Bosch was affected by the fear of a catastrophe associated with water.

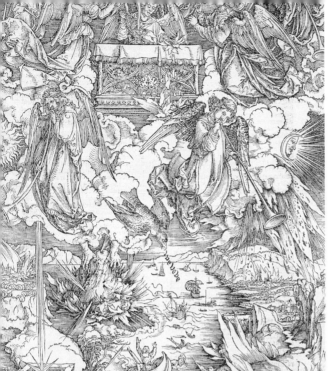

■ Dürer, *The Flagellants of the Apocalypse*, 1498, In the first extremely powerful series of engravings inspired by St John's Gospel, the German painter illustrates the disaster brought about by the combined natural forces of water and fire.

■ Peter Bruegel the Elder, *Gloomy Day*, 1565, Kunsthistorisches Museum, Vienna. In the background of one of his darkest paintings, Bruegel depicts a fierce storm that is sweeping away a number of boats on the river.

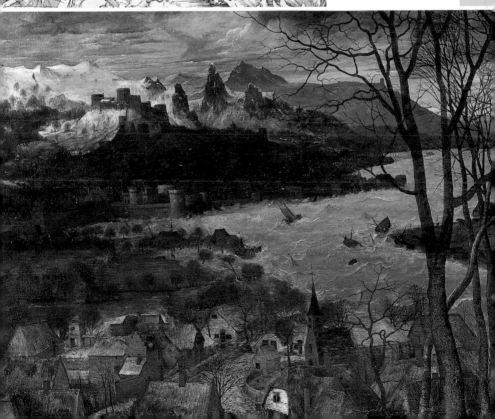

Flemish painting in the late fifteenth century

The great Flemish masters, such as Van Eyck and Van der Weyden, appeared in the first half of the 15th century. By the century's end, the influences of their elegant, meticulous realism had spread to the northern provinces where painting was gradually changing. Many of the Dutch "primitives", as these painters were known are not specifically identified, but

■ Master of Alkmaar, *Corporal Works of Mercy*, 1504, Rijksmuseum, Amsterdam.

 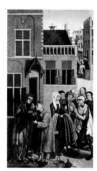 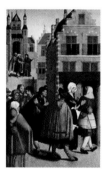

are known only by generalized names, and are represented here by significant works that bear certain associations with the style and content of Bosch's own paintings.

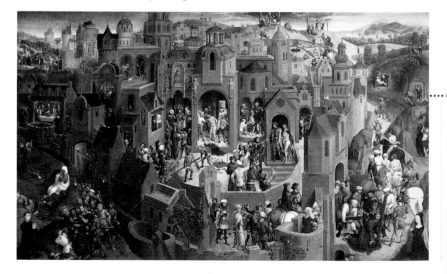

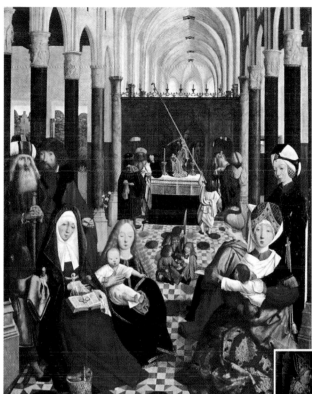

■ Geertgen tot Sint Jans, *The Virgin's Kindred*, c.1490, Rijksmuseum, Amsterdam. Geertgen, who was active in Leyden, was the most significant of truly Dutch painters at the end of the 15th century. His style was inspired directly by the great masters of Flemish art, and demonstrated an instinct for deep perspective and for meticulously analyzed detail; but the feeling and humanity with which he depicted everyday scenes genuinely anticipated the artistic realism of the Low Countries that blossomed in the centuries to come.

■ Jan van Eyck, *Madonna with Canon van der Paele*, 1434, Groeninge Museum, Bruges. Van Eyck dominated Flemish art up to the beginning of the 16th century.

The example of Memling

The most interesting Flemish painter of the second half of the century was Hans Memling, who was active mainly in Bruges, illustrated here by the very lively *Passion of Christ* (c.1480, Galleria Sabauda, Turin). Memling was a notable precursor of Bosch by virtue of his ability to crowd dozens of events and characters into a single, detailed landscape.

■ Master of the Virgo inter Virgines, *Virgin with Child and Saints*, c.1480, Rijksmuseum, Amsterdam. This painting gave its name to an anonymous, delicate painter from Amsterdam: the four saints who stand around the Virgin in the precinct of the *hortus conclusus* can be identified by the jewels they wear.

Bosch in documents: an uneventful, quiet life

The artist lived and worked in the town of 's Hertogenbosch. Documents preserved in the local archives furnish only the most fragmentary information about the painter's biography. Thus in 1480 he is known to have married Aleyt Goyaerts van de Meervenne, who came from a wealthy aristocratic family. The marriage served Bosch as a social springboard in the tranquil but confined local community: by 1486–87 he was already registered as a "notable member" of the Brotherhood of Our Lady, a religious association dedicated to the worship of the Virgin and to charitable works. His name appears on numerous occasions in the account books of the congregation. From 1488 the annual "swan banquet" of the brethren took place and Bosch, as the only painter registered at that time, received several commissions, ranging from a high altarpiece to a model for a candelabrum. It was in fact the chapel of Our Lady which, on August 9, 1516, held the funeral of the great artist, celebrated solemnly in keeping with the ways of the Brotherhood. There were no dramatic events to disturb the quiet life of Hieronymus Bosch, which he divided between his wife, his workshop, and the Brotherhood. The key to understanding the seething passion evident in his paintings must be sought elsewhere.

■ Bosch, *The Marriage at Cana*, 1475–80, Boymans-Van Beuningen Museum, Rotterdam. A number of malevolent and disturbing details haunt this untraditional version of of the biblical episode.

■ Bosch, Triptych of *The Garden of Earthly Delights*, detail of the *Musicians' Hell*, 1503–4, Museo del Prado, Madrid.

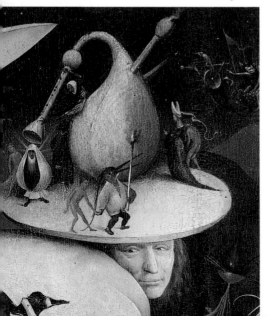

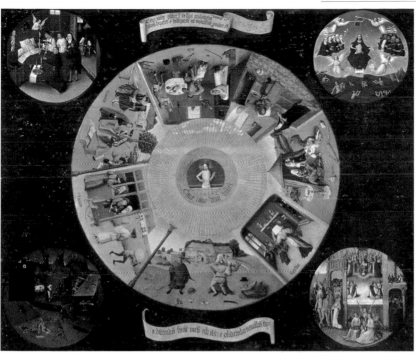

■ Bosch, *The Seven Deadly Sins*, 1475–80, Museo del Prado, Madrid. The four small circles around the central one show the *Four Last Things*.

■ Bosch, *The Marriage at Cana*, detail, 1475–80, Boymans-Van Beuningen Museum, Rotterdam. The swan was the symbol of the Brotherhood.

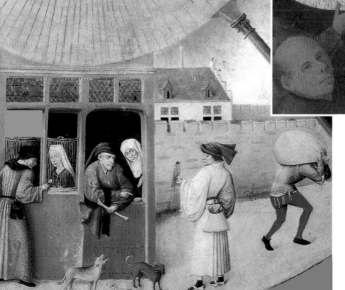

■ Bosch, *The Seven Deadly Sins*, detail of *Envy*, 1475–80, Museo del Prado, Madrid. The various sins are portrayed with stinging irony through the scenes of peasant life.

15

The Cure of Folly

Also known as *The Stone Operation*, the first of Bosch's paintings to be based on popular folklore, dating from about 1480, is now held in the Prado in Madrid. At that time, the saying "to have a stone in the head" meant to be mad.

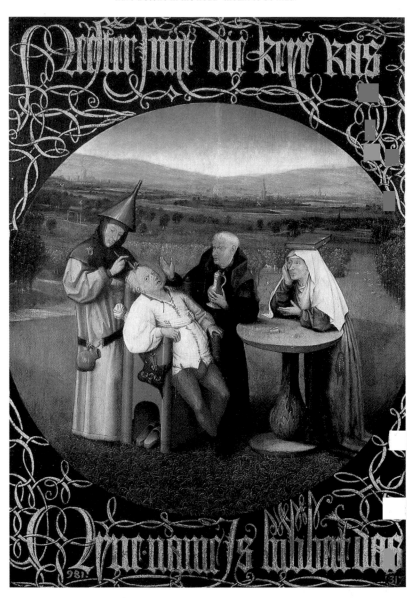

■ Detail of a 16th-century engraving inspired by the work of Bosch.

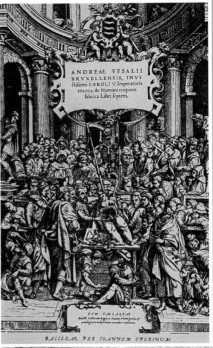

ANDREAE VESALII
BRVXELLENSIS, INVI-
ctissimi CAROLI V. Imperatoris
medici, de Humani corporis
fabrica Libri septem.

CVM CAESAREAE

BASILEAE, PER IOANNEM OPORINVM

■ Bosch, *The Cure of Folly*, detail, 1475–80, Museo del Prado, Madrid. The curious funnel-shaped hat of the surgeon symbolizes deceit

■ Andreas Vesalius, *Frontispiece to the Treatise of Anatomy*, 1540. First published in Basel and circulated through Europe, the treatise by the lecturer of Pavia University signalled the arrival of modern medical science.

■ Lucas van Leyden, *The Surgeon*, engraving, 1524. Although it lacks the grotesque and satirical features of Bosch, this splendid print shows the same surgical "operation" for the extraction of the "stone of folly".

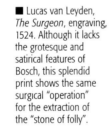

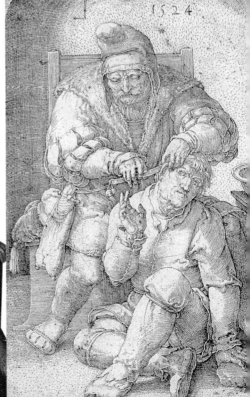

1524

BACKGROUND

Proverbs, folk culture, and the dawning of humanism

Imparting universal truths and received wisdom, proverbs provided the uneducated with a simplistic moral world view. At the turn of the 15th/16th centuries there was renewed interest in northern Europe for proverbs, sayings, and mottoes. In 1500, the *Adagia* of Erasmus of Rotterdam presented archaic proverbs as a summary of ancient wisdom, returning to earlier sources while acknowledging contemporary forms of popular culture, and pointing the way towards "modern" ideas in a manner typical of the Renaissance. Festivals and processions played an important part in the lives of late Medieval people: every year they celebrated the "feast of the ass" and the "feast of fools", but the climax came with the carnival, which filled the town streets for days on end, celebrating the temporary abolition of all taboos and regulations. It was that rich imagery, still medieval yet a part of contemporary life, that attracted Rabelais in his *Gargantua and Pantagruel*, published in 1532, and which was reflected in the art of Bosch and, after him, in the work of Peter Bruegel the Elder.

■ Bosch, *The Ship of Fools*, detail, c.1490, Musée du Louvre, Paris. The "tree of abundance" was well known in popular tradition.

■ Left, Peter Bruegel the Elder, *Twelve Netherlandish Proverbs*, details, 1558, Mayer van der Bergh Museum, Antwerp.

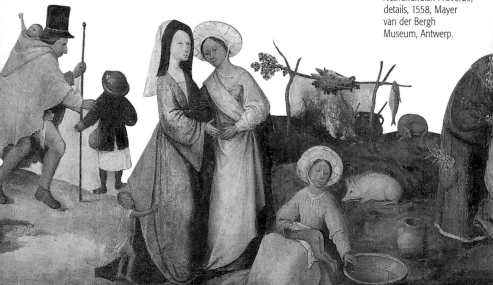

■ Bosch, *This
Field Has Eyes,
This Wood Has Ears*,
Kupferstichkabinett, Berlin.

■ Quinten Metsys,
Triptych of St Anne,
1509, Musée Royaux
des Beaux-Arts, Brussels.

■ Bosch, the *Hay Wain*
tryptic, detail, c.1500,
Museo del Prado,
Madrid. This scene
depicts peasant life.

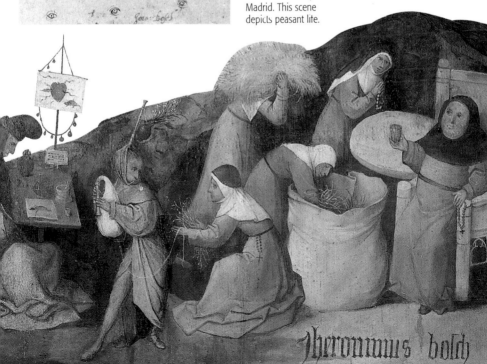

Religious devotion and the "Imitation of Christ"

Alongside the proverbs, a significant role in the culture of Bosch was played by the catechism and religious observance. The best known book of prayer was the *Imitation of Christ* by Thomas à Kempis, which outlined the fundamentals for a thorough renewal of Christian devotion throughout Europe, so much so that it is possible to recognize in it certain elements that herald the Protestant Reformation. In particular, it insisted on the need to project upon contemporary reality the events and personalities of sacred history, to the point of immersing oneself in the life and passion of Christ. To obtain a particularly realistic effect, he suggested giving the protagonists of the Gospel the features of people known to the artist and siting the episodes in familiar everyday rural or urban locations. This recommendation explains the peculiar character of 15th-century sacred painting, always set in a period context. The focus of the preachers on the wounds and agonies of Christ found the broadest response in the figurative arts, favoring the diffusion of *Christus patiens*, the Man of Sorrows. In Bosch's cultural sphere, where popular ancestral beliefs and humanistic morals are often combined, there can be no doubt that the Lenten sermons of the preaching friars, the pious practices of the Brotherhood, and the exhortations of the parish priest had a deep impact. Mysticism and fear, spiritual tension and superstition, combine to form powerful constraints.

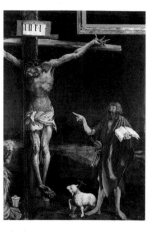

■ Mathias Grünewald, *Crucifixion*, detail, 1512–15, Musée d'Unterlinden, Colmar, France. A disconcerting sacred painting, in which St John points to Christ on the cross as an example to humanity.

■ Antonello da Messina, *Pietà*, detail, c.1476, Museo del Prado, Madrid. In Italian painting, too the agony of Christ is repeatedly represented.

Bosch and the Via Crucis

The *Ascent to Calvary* (c.1490, Kunsthistorisches Museum, Vienna) is one of the key pictures for the understanding of Bosch's religious beliefs. Without resort to fantastic creatures, the painter shows the savagery of the crowd around Christ, while a friar, below, hears the confession of the thief prior to execution, hoping for possible salvation. On the reverse is the enigmatic depiction of a child with a walking-frame.

■ Bosch, *The Seven Deadly Sins*, detail of the central sunburst, 1475–80, Museo del Prado, Madrid. Around Christ in the sepulchre is the Latin inscription *Cave cave, Dominus videt*: "Beware, beware, the Lord sees".

■ Bramantino, *Man of Sorrows,* c.1490 , Thyssen Collection, Madrid.

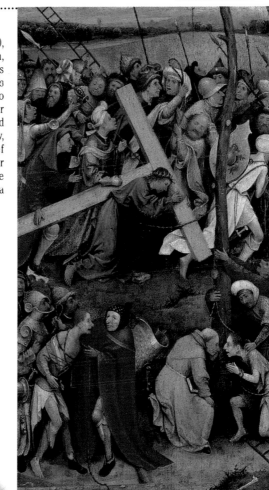

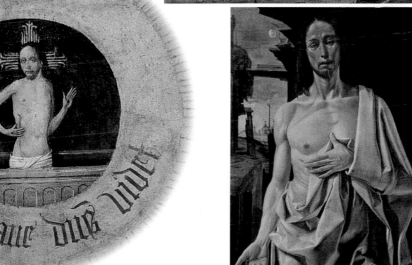

21

The Conjurer

A bitter and ironic reflection on the stupidity of common folk, easy prey for the tricks of charlatans, this painting, in the Musée Municipal of St Germain-en-Laye, is an early work, dating from between 1475 and 1480.

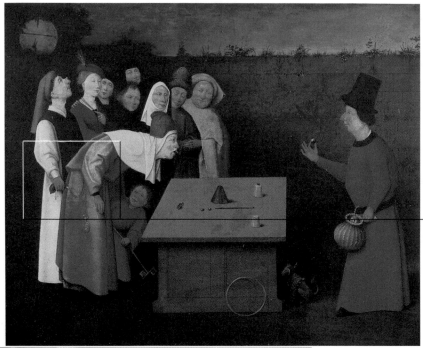

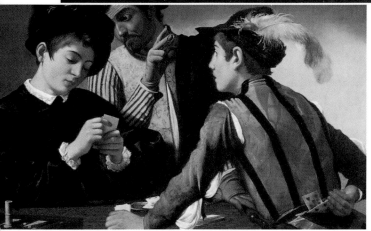

■ Caravaggio, *The Cardsharps*, 1594–5, Wadsworth Athenaeum, Hartford, Connecticut. The Caravaggesque iconographic device originated a series of works by his followers devoted to the subject of card-playing. Particularly successful was the Mantuan Bartolomeo Manfredi (1580–c.1624), who transformed the earlier example into pure genre painting.

■ Georges de La Tour, *The Sharper*, c.1630, Collection Landry, Paris. Trickery at the table: furtive glances between the accomplices, and two concealed aces. The theme of the duping of a simpleton is ably handled by Bosch in *The Conjurer*, but De la Tour extends the idea to include the additional notion of feminine seduction.

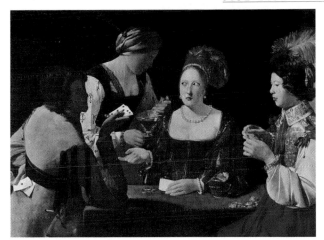

■ While the innocent victim gazes with rapt amazement at the tricks of the charlatan, a bespectacled accomplice behind him, with an air of studied indifference, removes his money purse. Episodes like this were common at the time of Bosch, as is confirmed by a Dutch text from 1483, which devotes a chapter to conjurers who trick the gullible into the expectation of an easy win.

■ Peter Bruegel the Elder, *The Misanthrope*, 1568, Musei e Gallerie di Capodimonte, Naples. An old man in a black cloak is robbed by a beggar wrapped in a crystal sphere, which alludes to the earth. Bruegel condemns evil, as is confirmed by the inscription in the lower part of the painting: "Since the world is so treacherous, I dress myself in mourning."

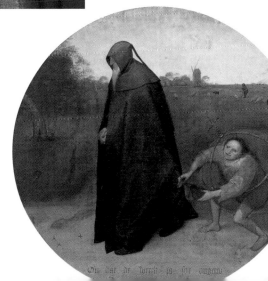

Bosch, *The Garden of Earthly Delights*, outer panels, 1503–4, Museo del Prado, Madrid

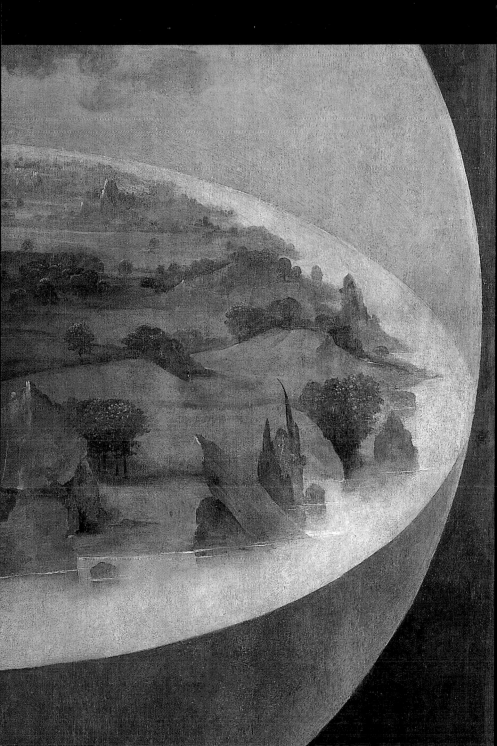

Bosch's culture and religion: theories and contradictions

The *Malleus Maleficarum*, the sermons of the monk Ruysbroeck, the *Vision of Tondalus*, the *Art of Dying*, *The Ship of Fools* by Brant, and the *Golden Legend* by Jacob of Varagine, are just a few of the literary sources that fuelled the creative mind of Bosch. The breadth of references demonstrates a heterogeneous culture, mostly medieval; but his open-minded approach to them renders the position of the painter, vis à vis the manifold problems here represented, wholly indecipherable. Works of traditional iconography alternate with sacrilegious and diabolical versions of religious themes, so that even though Bosch was a member of the Brotherhood of Our Lady he could still be accused of sympathizing with the ideologies of the heretical sects that proliferated in 16th-century Holland.

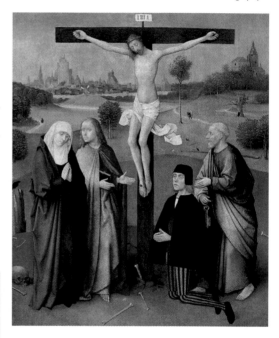

■ Bosch, *Crucifixion*, 1480–85, Musées Royaux des Beaux-Arts, Brussels. This youthful painting follows traditional iconography.

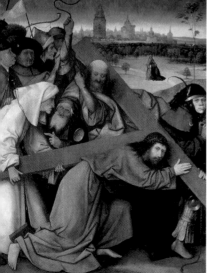

■ Bosch, *Ascent to Calvary*, c.1505, Palazzo Reale, Madrid. Themes associated with the life and passion of Christ are represented as examples on which to meditate.

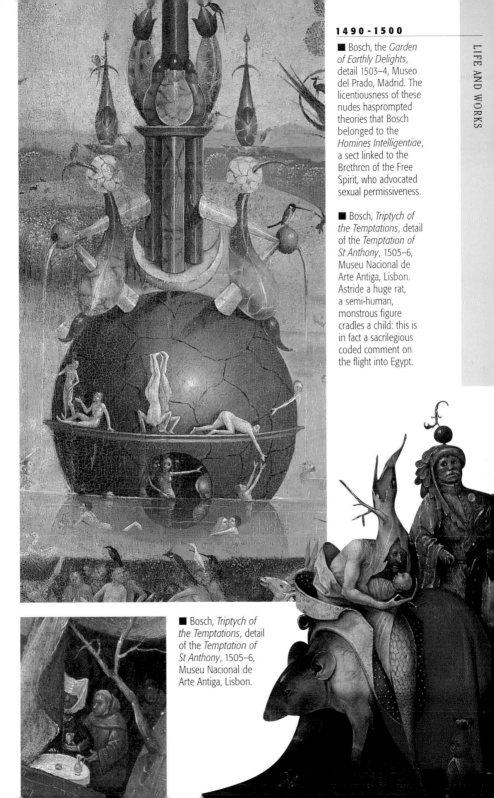

■ Bosch, the *Garden of Earthly Delights*, detail 1503–4, Museo del Prado, Madrid. The licentiousness of these nudes hasprompted theories that Bosch belonged to the *Homines Intelligentiae*, a sect linked to the Brethren of the Free Spirit, who advocated sexual permissiveness.

■ Bosch, *Triptych of the Temptations*, detail of the *Temptation of St Anthony*, 1505–6, Museu Nacional de Arte Antiga, Lisbon. Astride a huge rat, a semi-human, monstrous figure cradles a child: this is in fact a sacrilegious coded comment on the flight into Egypt.

■ Bosch, *Triptych of the Temptations*, detail of the *Temptation of St Anthony*, 1505–6, Museu Nacional de Arte Antiga, Lisbon.

End-of-century anxieties, sects, and dissent

Although Bosch's religious beliefs are sparsely documented, any conjectures about them must take into account the particular culture of Europe at the end of the 15th century: a complex web of superstitions, heresies, mystic pronouncements, itinerant preachers, and religious brotherhoods. This clearly point to a widespread need for a moral and spiritual renaissance. Apart from tragic and sensational events, such as the fates of Jan Huss and Girolamo Savonarola, there were innumerable signs of doubt and dissent that represented a challenge to the primacy of Rome and the Catholic church. According to Wilhelm Fraenger, Bosch subscribed to a sect of "millenarians", convinced of the imminent return to earth of Christ to usher in a kingdom of love that would last a thousand years. Although this intriguing theory has been revealed to be without foundation, it does focus attention on the tormented state of Christianity before the arrival of Luther, in a period distinguished by the committed and diligent activity of Erasmus.

■ In 1496 the burning at the stake of Savonarola (in this realistic contemporary painting) marked the extreme reaction against "licentiousness" in the Florence of the Medicis.

■ Lucas van Leyden, *Lot and His Daughters*, detail, c.1520, Musée du Louvre, Paris.

■ Lucas van Leyden, *The Sermon,* detail, 1530, Rijksmuseum, Amsterdam. Popular preachers were hugely influential.

■ Bosch, *Triptych of the Delights*, details of the *Musicians' Hell*, 1503–4, Museo del Prado, Madrid. The sow wears a nun's veil.

■ Rogier van der Weyden, *Last judgment*, detail with a damned person. Musée de l'Hôtel-Dieu, Beaune. Mental torment expresses the mortal terror of damnation.

This dread was exploited by unscrupulous clergy who grew rich by selling indulgences, expensive certificates of absolution, a practice that was widely condemned and paved the way for reforms.

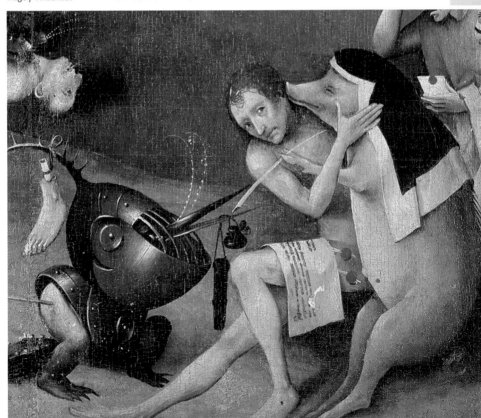

The Hay Wain

Corrupt, frail humanity, by now prey to folly and on the road to damnation, is the theme of the central panel of the *Hay Wain* Triptych, dating from between 1500 and 1502, the first great moral and satirical allegory by Bosch, in the Prado, Madrid.

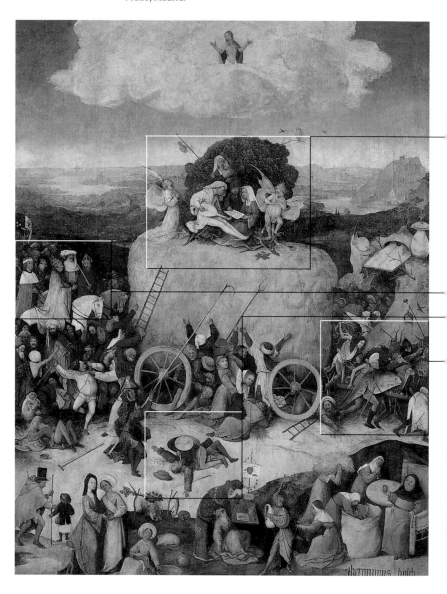

■ On top of the wagon, far removed from the giddy tumult that is going on below, sit those who are guilty of the sin of lust: a pair of peasants embrace among the bushes, while otherothers play worldly, sinful, and lascivious music, accompanied by a demonic figure piping a tune through his nose, and luring the angels on the left.

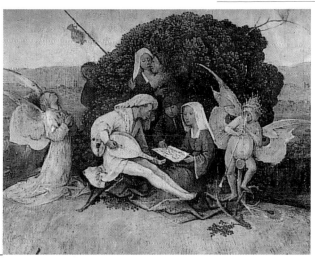

■ Among the sumptuously dressed figures on horseback it is possible to identify the king of France, the emperor, and the pope: not even the great rulers of the earth are free of corruption and sin, and they are placed by Bosch at the head of the frenzied procession.

■ The hay wain, a symbol of human frailty and the worthlessness of worldly gain is dragged slowly toward hell, depicted in the right-hand panel, by a group of monstrous characters, hybrid creatures that are part human and part animal. Among them is a fish with scales, an ironic allusion to lost purity. A torn text, in the form of a standard, precedes the demonic procession.

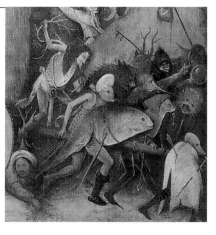

■ The scene of a homicide represents the culmination of the violence of which man, blinded by the desire for possessions, is capable. The principal theme of the central scene of the Triptych is the illustration of the old Flemish proverb, relating to greed: "The world is a heap of hay; everyone grabs some while he may".

The Hay Wain left panel

Four distinct episodes, the fall of the rebel angels, the creation of Eve, Original Sin, and the expulsion of Adam and Eve, proceed from the background to the foreground, each divided by leafy woodland vegetation.

■ The angels punished by God, as they fall, are reduced to a swarm of unearthly insects, winged salamanders, and devils, cast down into the lake and onto the ground by the might of Christ, ruler of the universe.

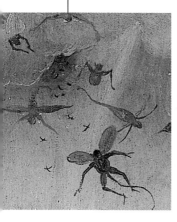

■ Bosch's version of Original Sin follows the biblical tradition: the serpent is coiled around the Tree of Knowledge of Good and Evil. The episode is treated in the left-hand panel of the triptych of the *Last Judgment* (c.1504, Academy of Fine Arts, Vienna), in which the serpent is transformed into a hybrid creature, with a woman's torso and the winding tale of a huge snake.

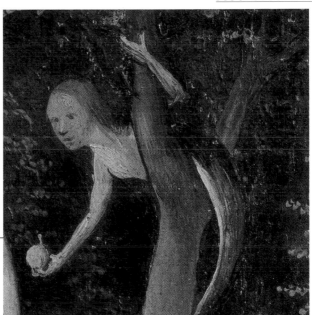

■ This plant, covered in thorns and producing strange fruit, is similar to the one in the foreground of *St John the Baptist in the Wilderness* (c.1504) from the panel in the Museo Lázaro Galdiano, Madrid. In both cases the thorns and fruit symbolize the temptation of the senses, and the dire consequences.

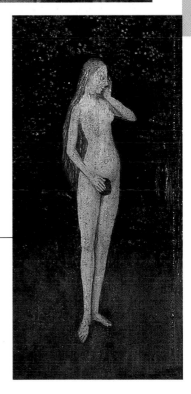

■ Eve, at the moment of the expulsion from Eden, is composed and resigned: the slender, naked figure of the woman is associated with the late Gothic tradition still active in northern Europe in the early 15th century of the miniature. Only near the end of his career did Bosch's figures take on a broader, more three-dimensional quality, under the influence of the Italian Renaissance.

Hell and Paradise: the architecture of fantasy

Representations of Paradise and, more frequently, Hell recur throughout Bosch's work. The biblical image of Paradise assumes unique and bizarre features: the traditional Eden, with its luxuriant trees and fruits, is embellished with unusual buildings formed of pastel-toned rocks and plant growths. For his vision of Hell, the artist, with his love of architecture, drew inspiration from apocalyptic literature and the imagery of Babylon; the epitome of the infernal city, as opposed to "celestial" Jerusalem: for Bosch, Hell becomes a veritable incandescent city. An emblematic instance is the right-hand panel of the *Hay Wain* Triptych (c.1500, Museo del Prado, Madrid), where devil-laborers are busy building a gigantic tower. The enormous construction strikes one as a parody of the Tower of Babel, here designed to house the tormented souls of the damned, who, in the pessimistic and fatalistic opinion of Bosch, constitute virtually the whole of humanity itself.

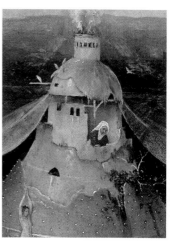

■ Bosch, the *Temptation of St Anthony*, detail, 1505–6, Museu Nacional de Arte Antiga, Lisbon.

■ Bosch, *the Garden of Earthly Delights* tryptic, detail, 1503–4, Museo del Prado, Madrid. Outlines of imaginary buildings are silhouetted against the background, with pleasing colored blends of pink, blue, and green. Fantastic geometric reworkings of Gothic cathedrals are fashioned from rocks and branches of exotic trees: perhaps this conforms to the "golden homes" destined for the blessed, as described in the vision of St Gregory.

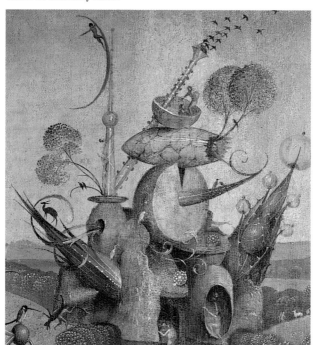

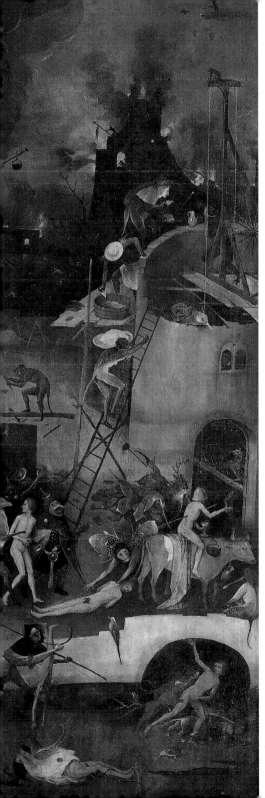

■ Bosch, *The Hay Wain* Triptych, right wing, c.1500, Museo del Prado, Madrid. The detail on the right is from the same work.

■ Bosch, *the Garden of Earthly Delights* tryptic, detail, 1503–4, Museo del Prado, Madrid.

Journeys into
the unknown

■ Bosch, *Triptych of the Last judgment*, outer panel with *St James of Compostella*, c.1504 , Academy of Fine Arts, Vienna. St James was the image, par excellence, of the pilgrim.

The life of Hieronymus Bosch, like that of any other reasonably knowledgeable European of his time, was profoundly affected by geographical discoveries. It was not so much a matter of amending the map of the world or the occasional availability of some exotic product: above all, the appearance of new continents, following the voyages of Columbus, Vasco da Gama, and Magellan, had psychological consequences. While Europe as a whole was emerging from its "medieval autumn", placing its trust in the solid certainties of humanist culture, it was suddenly forced to recognize that the world was much bigger, that the earth was populated by other races, that ships, within a matter of weeks, could reach lands hitherto entirely unknown. This awareness threw open the doors to a universe that demanded a different form of navigation, not restricted to a few crews of courageous pioneers but accessible to all: a journey into the self, into the secret regions of the human mind. Physical and mental boundaries alike demanded revision.

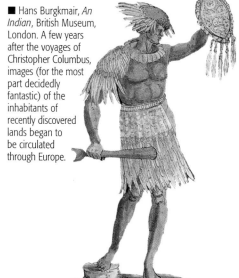

■ Hans Burgkmair, *An Indian*, British Museum, London. A few years after the voyages of Christopher Columbus, images (for the most part decidedly fantastic) of the inhabitants of recently discovered lands began to be circulated through Europe.

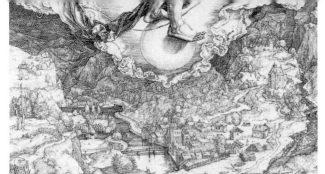

■ Dürer, *Nemesis*, engraving, detail of landscape. Like Leonardo, the great German painter also imagined bird's eye views of broad stretches of countryside.

Conquest of a happy land

The painting by Burgkmair shown below ingeniously illustrates the conquest of the "New Indies": the fantastic landscape recalls the backgrounds of Bosch. Apart from the commercial results of the geographical discoveries and the arrival of new foods that would become fundamental constituents of the European diet (maize, tomatoes, and potatoes), for some intellectuals and fantasists the lands overseas carried the illusion of a happy place, an Eden, a "city of the sun", where a new civilization could be established.

■ Giovanni Stradano, *Geography*, engraving, 1570. The 16th century saw rapid progress in the areas of geography, cartography, and shipbuilding techniques.

1490-1500

Ecce Homo

Painted at the end of his early style (1480–5), the version in the Städelsches Kunstinsitut, Frankfurt, is the first of a repeated theme in Bosch's work. Some of the donors are recognizable below.

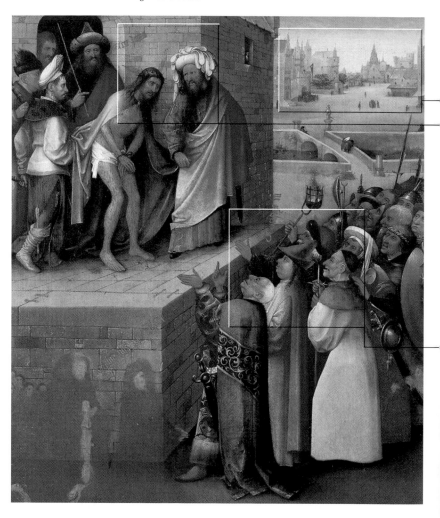

■ The view of a town in Brabant forms the background to the main scene. The town hall is adorned with a flag bearing a white half-moon on a red ground: this is one of the symbols of evil present in the work. There is no perspective, and in fact no graduation of the landscape from background to foreground.

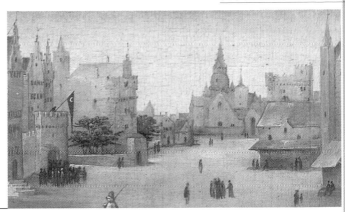

■ The message of the painting is the contemplation and meditation upon the suffering of Christ. The contrast between good and evil in the world is exemplified by the faces of Jesus and Pilate who are silhouetted against the walls of the building. Thus the features of Jesus register the composure and resignation of grief, turning an indulgent gaze toward the angry crowd below, while the tyrant grimaces with a sardonic leer.

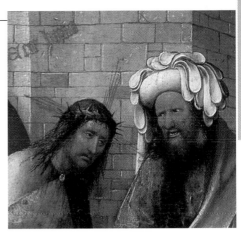

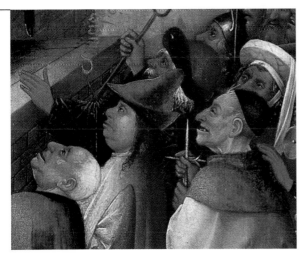

■ The crowd of Christ's accusers, armed with halberds and daggers, is portrayed by Bosch in a moral and metaphorical fashion. The deformed and almost animal-like features of the mob epitomize the essence of evil, and they seem to form themselves into a single, monstrous, and many-headed creature. In this section the figures are portrayed with uneven lines, marking the end of the artist's formative phase.

A satirical best-seller: "The Ship of Fools"

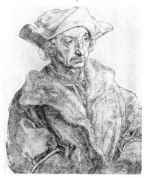

■ Dürer, *Portrait of Sebastian Brant*, 1521. This penetrating sketch was done while the painter was travelling in the Low Countries, almost 30 years after the publication of *The Ship of Fools*.

One of the most important books of the late 15th century, and a direct source of inspiration for Bosch, was *Das Narrenschyff* (*The Ship of Fools*), a long satirical poem written by the Strasbourg humanist Sebastian Brant. A famous and erudite doctor of law, Brant's complex and weighty venture into poetry (103 chapters mostly written in the Alsatian dialect) enjoyed rapid and widespread success, with numerous translations. The poem is an allegory of the vices and failings of a sick society, tainted by sins, discord, and spiritual unrest. A group of mad people embark on a ship and sail to Narragonia, the promised "fools' paradise"; before being finally wrecked, the ship puts in at the mythical country of Schlaraffenland – the land of plenty. Each of the numerous individual episodes, some of them laborious allegories that feature obscenity and degradation, is accompanied by a powerful woodcut illustration, a major reason for the book's success.

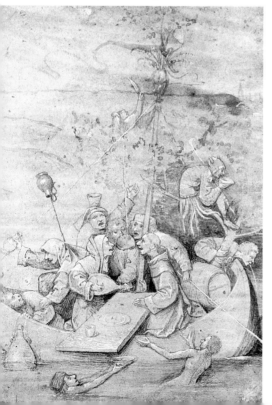

■ Bosch, preparatory drawing for *The Ship of Fools*, 1490–1500, Musée du Louvre, Paris. The drawing, one of the most important of all Bosch's graphic works, conforms in virtually every respect to the composition and details of the completed painting reproduced on the facing page. The finished quality gives the impression of a drawing ready to be engraved, or even used as an illustration to Brant's massive book.

■ Two woodcuts from the first edition of *Das Narrenschyff* by Sebastian Brant, published in 1494, considered by some critics to be among the very first engravings of the 20-year-old Dürer.

■ Bosch, *The Ship of Fools*, 1490–1500, Musée du Louvre, Paris. At the end of the 15th century the line between madness and sanity was very flexible and often blurred, and those perceived to be mad were not socially humiliated or excluded. Often the voice of God was deemed to be heard through the mouths of the insane, who were permitted to roam the countryside and villages, or taken aboard the so-called "blue ship" which sailed everywhere. Attracted by the allegory, Bosch filled his ship with fools from different walks of life, skilfully mingling realism, metaphor and allegory with the diabolic and the obscene. The helmsman plays the bagpipes, conforming exactly to Brant's written description. The result is exceptional, and its effective synthesis of themes, accuracy of representation, and graphically portrayed characters, proved a more successful reworking than any of the other literary reinterpretations.

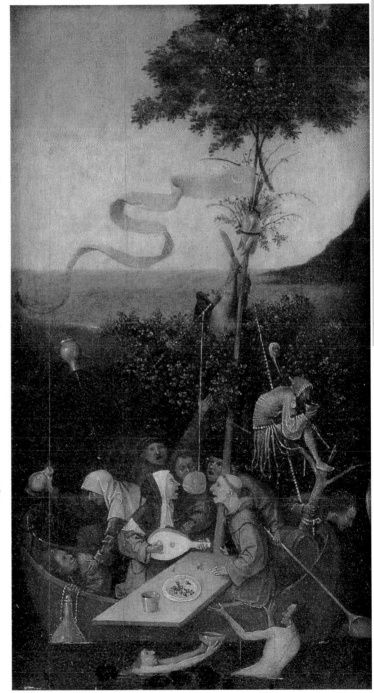

Death of the Miser

The shape, the dimensions, and the state of preservation suggest that this panel, dating from 1490–1500 and today in the National Gallery of Art, Washington, is the outer wing of an unidentified triptych.

■ Death is portrayed as a skeleton who is preparing to strike at the dying miser with a long spear.

■ Two anonymous woodcuts from *Het sterfboek* (*The Book of Death*), 1488. The booklet, a Dutch edition of the *Ars moriendi*, enjoyed enormous success in the Low Countries in the early Medieval age and was undoubtedly one of Bosch's sources.

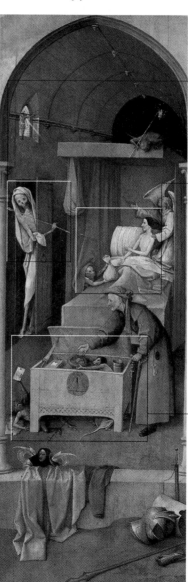

■ The miser, even when confronted by death, turns his back on divine law, as represented by the guardian angel who pleads for him, directing him toward the crucifix, and reminding him for the last time of his sins. Rather, the dying man stretches out his hands to grasp the bag of money offered to him by a devilish creature from behind the curtain.

■ At the foot of the bed, an old man, himself approaching death, is busy placing some gold coins inside a huge casket, heedless of the rosary which he holds in his left hand. Below and inside the coffer are monstrous animals representing evil, again triumphant in the eternal struggle against good.

■ Bosch, *The Seven Deadly Sins,* detail of *Death,* one of the *Four Last Things* 1475–80, Museo del Prado, Madrid. The skeleton of death, who enters furtively with spear in hand, the conflict between the angel and the devil, and the avarice of humanity, represented by the wife of the dying man, who counts her inherited money in the background, are, as in *Death of a Miser,* all present in this episode.

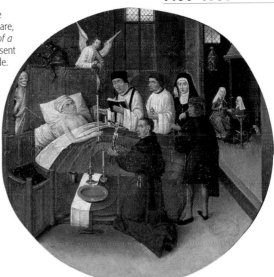

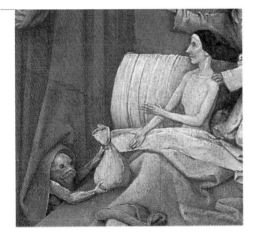

■ Bosch, *Death of the Miser,* preparatory drawing, 1490–1500, Musée du Louvre, Paris.

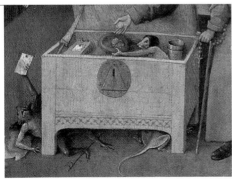

Local employment and foreign commissions

Among Bosch's clients were the Van Hoss and Bergh families, two of the most eminent in 's Hertogenbosch: in addition the artist worked for the Brotherhood of Our Lady and in other sites of his home town and neighboring villages. His fame soon extended beyond the restrictive bounds of his local community: and it was to him that Philip I, duke of Burgundy, turned for the painting of a *Last Judgment*, identifiable either with the triptych of Vienna or the *Judgment* of Munich. Furthermore, in 1516 a *St Anthony*, not otherwise identified, belonged to Margaret of Austria, regent of the Low Countries and sister to the same Philip, while in 1521 Cardinal Grimani already possessed some three works by Bosch in his Venice collection. Such a wide diffusion of paintings, actually during the painter's lifetime, puts into question the assertion that Bosch never left his native country.

■ Master of Alkmaar, *Visiting the Sick,* 1504, Rijksmuseum, Amsterdam. Originally intended for the church of St Lawrence in Alkmaar, the panels of the unknown artist, possibly a native of Haarlem, and known alternatively as the Master of the Mercies, offer an interesting testimony to the well-ordered appearance of Dutch towns at the beginning of the 16th century. Other details are shown on page 12.

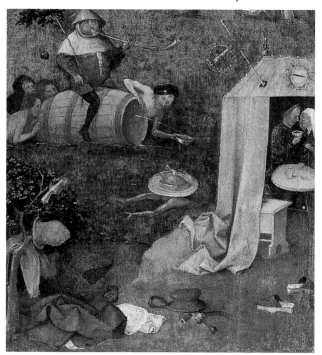

■ Bosch, *Allegory of the Pleasures,* 1490–1500, University Art Gallery, Yale. The coat-of-arms above the tent is that of the local Bergh family, who commissioned the painting.

■ Bosch, *Fall of the Rebel Angels*, left wing of a triptych c.1500, Boymans-Van Beuningen Museum, Rotterdam. Together with another panel, displayed in the same museum, this wing constituted part of an altarpiece triptych. The other wing depicts the flood, and the reverse is *Mankind Beset by Devils.*

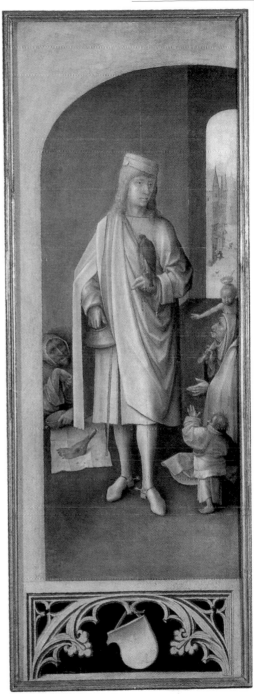

■ Bosch, Triptych of the *Last Judgment*, *St Bavo*, c.1504, Academy of Fine Arts, Vienna. This is the external right panel of the triptych, perhaps commissioned by Philip I.

The Garden of Delights

The central panel of the *Garden of Earthly Delights* tryptic, completed in about 1500 and now in the Prado, Madrid, is devoted to lust: in the center of the garden is a pool, full of cavorting naked women, surrounded by naked men astride fantastic animals.

■ Among the extraordinary animals populating the garden, there is, floating in the sky, a griffin; a curious cross between a lion and a bird of prey, ridden by a man holding a branch with a red bird. A common decorative motif, this mythical creature was said to keep guard over hidden treasures.The color red, was linked with the symbolism of alchemy, which pervades the whole scene: it refers, in fact, to the culmination of the creative process. The toad alludes to evil.

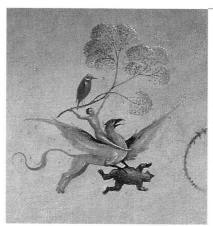

■ The sin of lust is exemplified by a pair of lovers, sensual and tactile, and surrounded by an immense transparent bubble, the outgrowth of a flower blossoming in the water. The motif of the glass sphere is associated both with the instruments of the alchemist and with an ancient Flemish proverb which says: "Happiness is like a glass, which soon breaks." The crystal tube inserted in the fruit underneath the bubble is a male emblem, while the mouse venturing inside is a reference to the false doctrines which draw believers into deception.

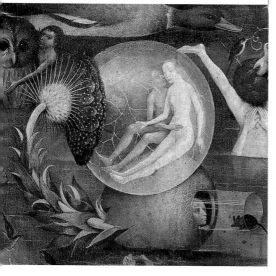

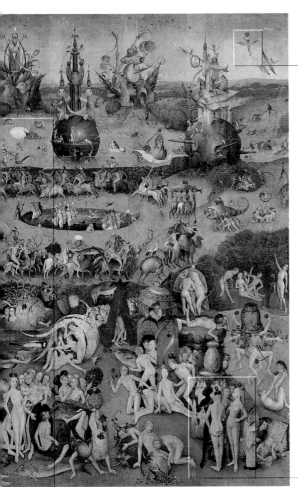

■ A winged human figure flies in the sky with a red berry: this is evidently an allusion to the transient nature of pleasure based primarily upon lust.

■ Black men and women sometimes appear among Bosch's characters: black, in alchemy, alludes to the first stage of matter. The naked, female figures illustrate the provocative image Bosch associated with women.

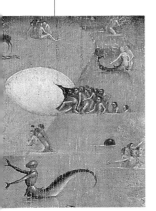

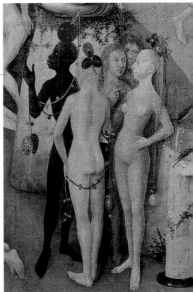

■ The source for Bosch's hybridcreatures between humans and fish can be identified: they are, in fact, derived from woodcuts illustrating *La mer des hystoires*, published in 1488. In the background, the egg in which groups of people take refuge refers to the crucible of alchemy, where chemical and magical transformations take place.

The Creation of Eve

The left-hand panel of *The Garden of Earthly Delights* does not represent the Temptation or the Expulsion, but the creation of Eve and the presentation of her to Adam by God in the guise of Christ.

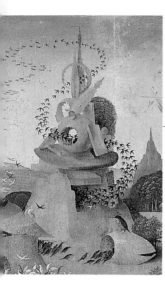

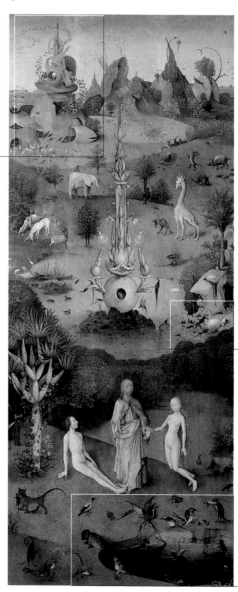

■ The construction of the scene is achieved by a superimposition of planes and a circular progression: the fantastic structures show natural elements mingling with solid geometrical forms. Flocks of birds fly among and outside the pinnacles of the colored edifices. The similarities between this architecture and the central panel of the garden suggest the same surroundings and link both episodes: the sin of lust is seen as the logical consequence of the creation of woman.

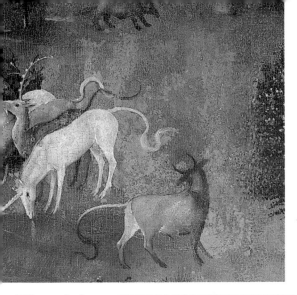

■ In the pool
that surrounds the
fountain, central to the
composition, fantastic
animals come to drink.
These are derived from
medieval bestiaries,
and include several
deer and a white
unicorn, the symbol
of mankind's purity
prior to Original Sin.
The same animals are
to be found among the
cavalcade of animals
in the central painting
further confirmation
that the two episodes
are probably linked.

■ The serenity of
the bright landscape
of the earthly Paradise is
only apparent: In certain
details, in fact, the evil
that permeates the
world creeps to the
surface and reveals
itself. The right side of
the pool is populated
by monstrous reptiles,
impossible creatures,
and black toads,
symbols of the devil.

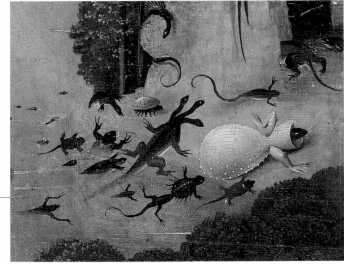

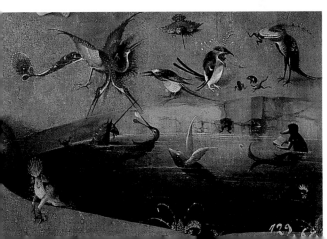

■ The pool of dark
water surrounded by
fantastic creatures marks
the thematic transition
from this painting and
the central garden
image: the dead fish
refers to sin, while the
creature with the long
nose reading a book is
a personification of
evil that recurs in
Bosch's work.

Musicians' hell

At the conclusion of the complex allegory conceived for the *Garden of Earthly Delights*, humanity, deaf to the divine laws and fallen irrevocably into sin, is horribly punished according to the laws of retribution.

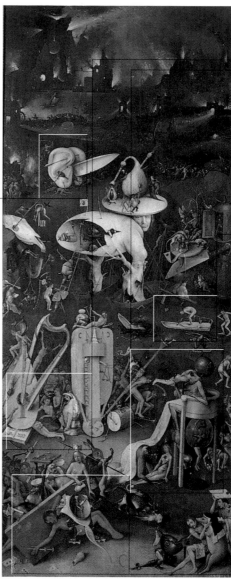

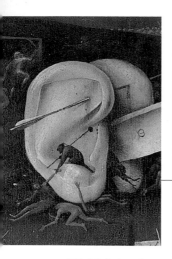

■ A diabolical creation is formed from a pair of enormous ears, impaled by an arrow and cut through by a long knife blade. There are many possible meanings: for some it is man's deafness to the evangelical saying: "Whoever has ears to hear, let him hear"; for others, however, it signifies earthly unhappiness. On the blade is inscribed the letter "M", seen on other knives in Bosch paintings and perhaps the initial of a cutler, or more likely the first letter of the word *Mundus (world)*. The blade also alludes to male sexuality.

■ The *Musicians' Hell* is so called because of the presence of instruments that are often improperly used: the lute is here a means of torturing a sinner, on whose buttocks are printed a melody, intoned by a choir of the damned, conducted by a monstrous singing teacher.

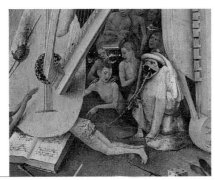

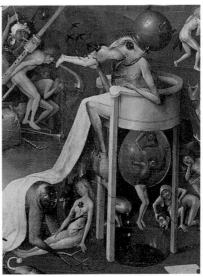

■ A creature with a bird's head swallows the damned and gets rid of them as excrement into the same pool where a miser is condemned to expel his gold coins, while another vomits up his meal, clearly a punishment for gluttony. At the foot of Satan's throne lies a naked woman with a toad impressed on her chest, her face reflected in a mirror attached to the backside of a demon: this is a punishment for having committed the sin of pride.

■ The literary source for Bosch's painting has been recognized in the *Vision of Tondalus*, published in 1482: the monstrous hallucinations of the medieval knight, as described in the poem, may have originated the idea of the frozen pool, the surface of which is crossed by sinners on strange sledges or wearing skates.

■ A table overturned after a quarrel sends the gamblers sprawling, one of them being attacked by a monstrous animal. This is how Bosch condemns the game of hazard, often the excuse for a brawl. It alludes to the punishment for the hot-tempered, as violent after death as they were in life. The knife that pierces the hand raised in blessing indicates the severity of the sin, capable of destroying Christ's charity.

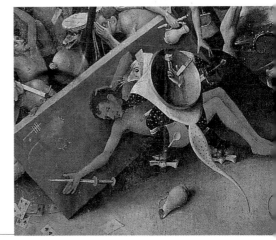

Witchcraft in ancient sources

Although early art literature concerning Bosch is comparatively sparse, all the 16th-century authors agree on the most conspicuous feature of the Dutch master's output: the presence of monstrous, composite creatures, diabolical conjunctions of human, animal, and vegetable parts, the creation of which was described by one Venetian critic as witchcraft. Many paintings by Bosch were subsequently taken to Spain, and Spanish authors of the Counter Reformation period emphasized the infernal aspect of these "strange likenesses of things" (Felipe de Guevara), "licentious fantasies" and "clever caprices" (Pachero). In Venice, where several works by Bosch and his imitators were found, commentators spoke of the free interplay of whim and fantasy, "a fabric of dreams" (Michiel), "chimeras, dreams, visions, and eccentricities, which teach fancy new inventions" (Boschini), and "infinite extravagances of forms, so that anyone who sees them is astonished and stupefied" (Zanetti). This imagery of marvels is challenged by the learned northerner Dominicus Lampsonius (1572) who focuses upon the "infernal" Bosch: "What are these things that you gaze upon, with your astonished eye and your pallid face? They are like ghosts of the dead, spectres from Erebus, that flutter before you."

■ Bosch, *The Temptation of St Anthony*, detail, 1505–6, Museu Nacional de Arte Antiga, Lisbon. The messenger bird on skates carries a sealed letter, alluding to the clergy who grow rich on the sale of indulgences to the credulous.

■ Bosch, *The Temptation of St Anthony*, 1505–6, Museu Nacional de Arte Antiga, Lisbon. "The big fish eats the smaller fishes" is one of the best known Flemish proverbs.

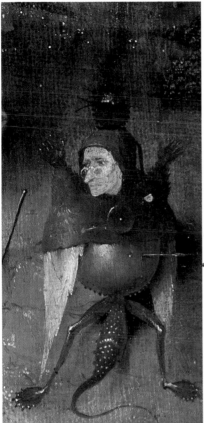

■ Bosch, *St John on Patmos*, detail, 1504–5, Gemäldegalerie, Berlin. The bespectacled little devil, old and sad, does not arouse the interest of the saint, wholly intent upon his vision of the Apocalypse.

■ Bosch, *The Temptation of St Anthony*, detail, 1505–6, Museu Nacional de Arte Antiga, Lisbon. Some of Bosch's monsters recall the "grylloi" (pigs) of Greek art.

■ Bosch, *The Last Judgment*, detail, c.1504, Academy of Fine Arts, Vienna. In hell, a couple of devilish female cooks are busy frying and roasting the damned.

Bosch's bestiary: zoology and fantasy

Animals are the main protagonists of Bosch's fantasy world. Beasts that evoke exotic lands, such as elephants and giraffes, known from zoological collections, appear alongside others more commonly found, chosen for the symbolic value that they serve in various medieval bestiaries. The fish,

when alive, thus becomes the emblem of of lust, or indeed of sin in general; the owl conveys either wisdom or heresy, according to context; and the toad is the devil incarnate. Creatures to be found in standard sources mingle with rare and fantastic beasts, monstrous hybrids created by the imagination of the painter, bent on provoking controversy in the moralizing vein of the ancient bestiaries. Gruesome figures, in which the bodies of reptiles unite freely with human faces, birds' wings, and insects' legs, impart a concrete image of evil which, in the universe of Bosch, underlies every aspect of existence.

■ Woodcut by Bartholomeus Anglicus, *Van der proprieteyten der dinghen,* Haarlem, 1485.

■ Left: Bosch, *Drawing with Sketches of Animals and Monsters,* Ashmolean Museum, Oxford.

■ Bosch, *The Garden of Earthly Delights,* detail of the *Earthly Paradise,* 1503–4, Museo del Prado, Madrid. Among the exotic animals are a unicorn, a monkey, and an elephant.

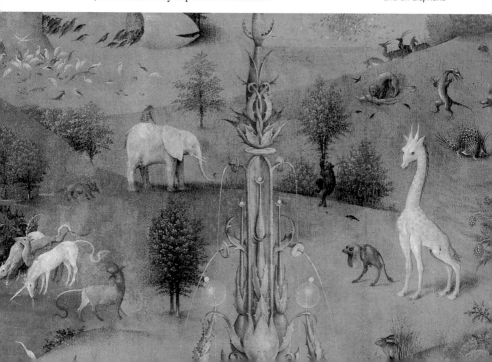

■ Bosch, *Drawings of Animals,* Ashmolean Museum, Oxford. Among the monstrous imaginary animals is a common bear.

■ Bosch, *The Temptation of St Anthony*, detail, 1510, Museo del Prado.

■ Bosch, *Altarpiece of the Hermits*, detail of the left panel, c.1505, Palazzo Ducale, Venice.

■ Woodcut of the *Dialogus creaturarum*, Gouda, 1480. The elephant, unicorn, and deer of *The Garden of the Delights* are echoed in this work.

55

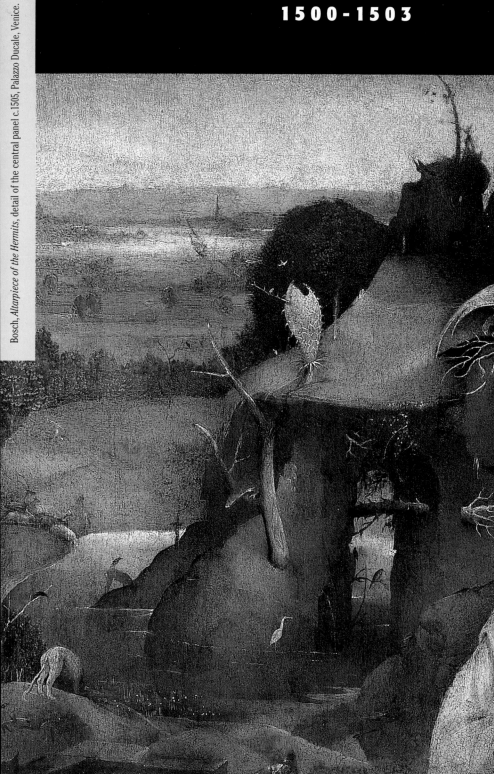

Bosch, *Altarpiece of the Hermits*, detail of the central panel c.1505, Palazzo Ducale, Venice.

Journey to Italy

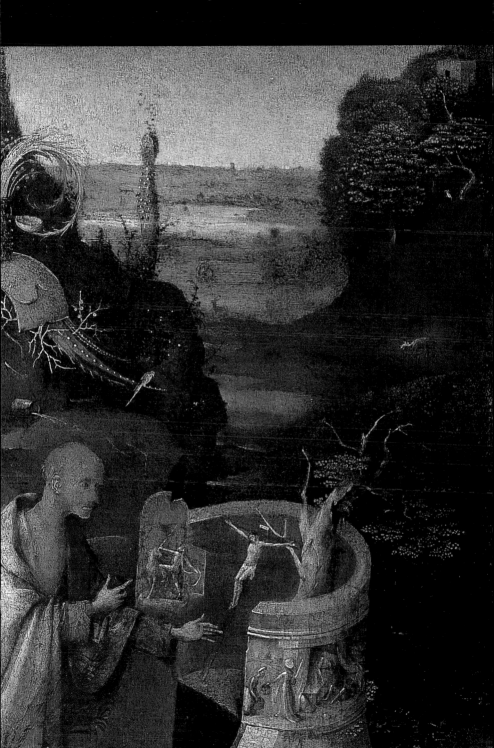

Bosch in Milan?
A controversial fresco

For some ten years one of the most studied and debated "cases" in Lombard painting was that of the fresco, its central part mutilated, which emerged during restoration work to the oratory of San Bernardo, a Gothic chapel situated inside the enclosing walls of the abbey of Chiaravalle, just outside Milan. According to some students, the painting is attributable to Bosch, so testifying to a Milanese visit, the first stage of a journey that took him to Italy around 1500–4. The evidence for the link with Bosch is based on representations of the grotesque and the deformed features of some of the people depicted in the scene of the meeting of Christ and Pilate. But there are alternative attributions, too, on the strength of indirect cultural evidence, ranging from Quinten Metsys to an anonymous master of Lombard origin. The suggested dates, indeed, fluctuate widely from 1460 to 1510, indicating the extreme difficulty in trying to accredit an undeniably fascinating work which cannot be compared with any other. The intriguing hypothesis that Bosch could have paid a visit to Milan reinforces the belief by some scholars that there might have been a direct relationship between Bosch and Leonardo da Vinci, his contemporary.

■ *Christ Before Pilate*, c.1500, Oratorio di San Bernardo, Abbazia di Chiaravalle (Milan): the central section of what may be Bosch's Italian fresco is irreparably damaged because of a large empty space.

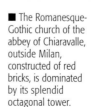

■ The Romanesque-Gothic church of the abbey of Chiaravalle, outside Milan, constructed of red bricks, is dominated by its splendid octagonal tower.

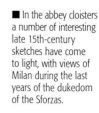

■ In the abbey cloisters a number of interesting late 15th-century sketches have come to light, with views of Milan during the last years of the dukedom of the Sforzas.

■ *Christ Before Pilate*, detail, c.1500, Oratorio di San Bernardo, Abbazia di Chiaravalle (Milan). The best-preserved portion of the fresco shows Christ, in resigned mood, surrounded by an inquisitive, sneering crowd. The scene is set inside the crenellated wall of Pilate's palace. The episode relating to the Roman governor's judgment is easily recognizable but has to be carefully considered: in Italian painting, in fact, it is very rare for this subject to be depicted on its own and not in the context of cycles devoted to the passion of Christ: understanding the reason for this particular choice of iconography may help to solve the mystery that still surrounds the fresco.

■ *Christ Before Pilate*, c.1500, Oratorio di San Bernardo, Abbazia di Chiaravalle (Milan), detail of dignitaries.

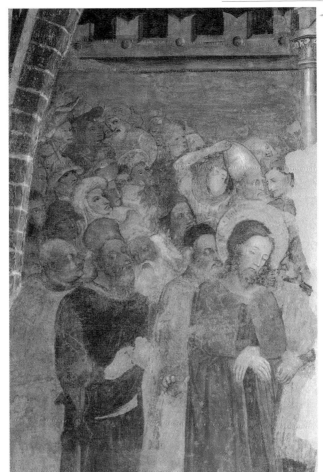

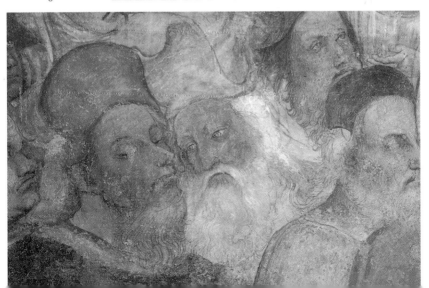

Leonardo and the image of nature

Ⅰt is certain that Bosch and Leonardo were very different types of artists, yet the two painters, who were exact contemporaries, may have met each other in Milan, where the Tuscan master moved to in 1482, or in Venice, where Leonardo took refuge after the downfall of Ludovico il Moro in 1499. In the works of both these men it is possible to recognize parallels. Leonardo called himself a "universal painter"; no aspect of nature, however small and insignificant, escaped the penetrating analysis of his gaze. Yet his ultimate objective was the representation of the "movements of the mind" – the feelings and emotions that agitated the heart and moulded the character. In Leonardo's works (and especially in his drawings) there is a combination of the vulgar and the sublime, the horrible and the marvellous, just as occurs in Bosch. Both painters are attentive and shrewd interpreters of a time of pivotal change in Western culture – many of their works strongly convey the perils of upsetting the universal equilibrium and of cosmic harmony constantly under threat from the forces of evil.

■ Leonardo da Vinci, *Branch of Wild Mulberries*, drawing, c.1490, Royal collection, Windsor.

■ Leonardo da Vinci, *Landscape with a River*, drawing, 1473, Gabinetto dei disegni, Galleria degli Uffizi, Florence, This is the earliest dated work by Leonardo (then aged 21), which reveals his strong interest in nature. However, it is evident that during this period the Tuscan painter allotted only a secondary role to landscape.

■ Leonardo da Vinci, *The Virgin of the Rocks*, 1483–86, Musée du Louvre, Paris. This groundbreaking work, completed for the church of San Francesco in Milan, was copied by a great number of artists.

■ Leonardo da Vinci, *The Last Supper*, detail, 1495–97, Cenacolo di Santa Maria delle Grazie, Milan. The overwhelming energy of this masterpiece made it an example for generations of artists to come.

■ Leonardo da Vinci, *Study of a Head for the Battle of Anghiari*, drawing, c.1503 Museum of Fine Arts, Budapest. The grotesque, deforming grimaces of many of Leonardo's faces draw parallels with the grotesque features in Bosch's work.

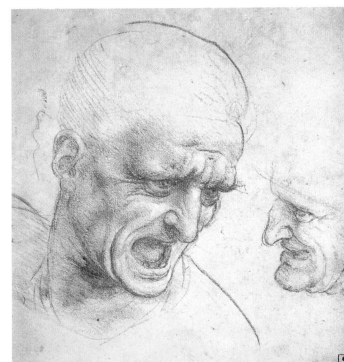

Grotesque monsters

At the opening of the 16th century there was a plethora of "ugly" images, and a revival of medieval "jokes", almost as a violent reaction against the ideal, classicizing elegance of the age of humanism. Bosch was undoubtedly the most prolific and imaginative creator of grotesque images, though certainly not the only one. But whereas the deformed features depicted by Bosch revealed the moral "monstrosity" of individuals, among artists more directly in the flow of Renaissance culture (such as Dürer and Giorgione), the grotesque provided the occasion for meditating upon the transitory nature of beauty and the frailty of human values over time. Here is the origin of the term "vanitas", the vein of melancholy reflection that became so popular in the Baroque age.

■ Mathias Grünewald, *St Anthony Beaten by Devils*, c.1516, Musée d'Unterlinden, Colmar. In this devilish frenzy there are creatures of all kinds, including hybrids of animals, humans, and plants.

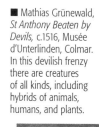

■ Quinten Metsys, *The Ugly Duchess*, c.1515, National Gallery, London. This was a dramatic parody of the aesthetic ideals of the Renaissance.

■ Quinten Metsys, *The Usurersi*, Palazzo Doria Pamphili, Rome. The Antwerp painter, like Bosch, has often been mentioned as having perhaps established some form of contact with Leonardo: it is not by chance that the name of Metsys has been suggested as one of the possible painters of the Chiaraville fresco (see pp. 58–59).

■ Bosch, *Christ Before Pilate*, 1480–85, Städelsches Kunstinstitut, Frankfurt, detail of one of the bystanders. In Bosch's paintings the people he most savagely caricatures are the morally degenerate: they often represent diabolical vices or symbolize the depravity that has afflicted the world with the spread of evil. It is worth emphasizing, however, that some faces which are apparently fanciful are actually images that cruelly resemble the symptoms of physical or mental disease, which was certainly very widespread at the time.

The Ascent to Calvary

The deformed, brightly colored heads in this painting(1503–4, Musée des Beaux-Arts), set out to depict the distorting effect of hatred and mockery. It is one of the most extraordinary examples of Bosch's tireless creativity.

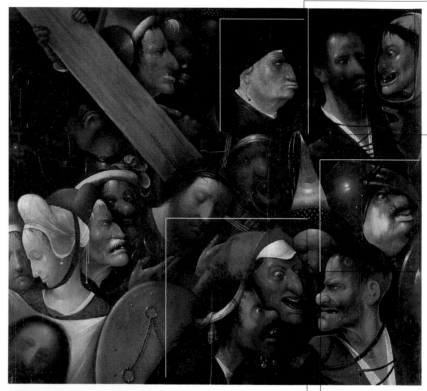

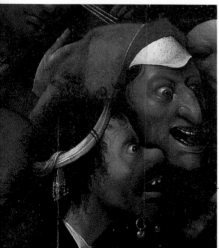

■ Disturbing characters crowd around Christ. Evil is no longer concealed in the form of symbols but by now embodied in human beings. Deformed features, hooked noses, shrunken ears, and toothless mouths emerge from the dark background, along with the brilliant colors of the headgear.

■ Faces in profile alternate with heads in frontal or three-quarter view, without leaving any free space. This technique suggests movement in the scene, with a whirling arrangement of nineteen figures, culminating in the serene face of Christ, following the diagonal line of the cross. The features and details suggest the meticulous studiers from life before caricaturing the faces.

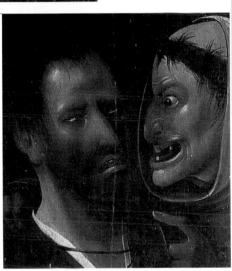

■ The penitent thief at top right seems consumed by terror and sin, intimidated by the menacing attitude of the figure by his side. The devilish features of this figure yet another allusion by Bosch to the corruption of the clergy. The eyes of the penitent are half-closed, like those of Christ and Veronica, on the same diagonal as those of the thief: in this way the good are isolated from the distressing spectacle of evil in the incarnation of mankind. The unrepentant thief at bottom right, however, prepares for his fate with a defiant sneer.

■ The devilish procession heading for Calvary is led by a guard with a gleaming helmet and shield. In contemporary depictions of characters, a short, thick neck and head was a sign of stupidity, while a large, wide mouth implied a person who was quarrelsome, deceptive, and evil.

Bosch in Venice

■ Bosch, the *Crucifixion of St Julia* Altarpiece, c. 1500–4, Venezia, Palazzo Ducale, Venice. The outer panels show St Anthony and the city in flames, and two figures at the port. (see pp. 68–69).

Between 1500 and 1504 there is no documentary evidence for Bosch's life or his movements, but there is a theory that the painter paid a visit to Italy during those years, including a long stay in Venice. The theory has gained credibility not only by reason of the recorded existence of certain works by Bosch in Venetian collections from the first decades of the 16th century, but also from precise stylistic cross-references between the development of Venetian painting and the evolution of Bosch's art, which from then on assumes a more solemn tone and monumental form, responsive to the atmosphere of the landscape. Many "northern" Renaissance painters considered it important to spend a period of study in Venice; for Bosch a journey to Italy would have been an important cultural experience. At this time the city was approaching the height of its magnificence and was a magnet for merchants, artists, and intellectuals of all nations. Such interrelationships and influences were, not surprisingly, reflected in the painting and architecture of the city.

■ Palazzo Ducale, Venice. The splendor of St Mark's illustrates the greatness of the city.

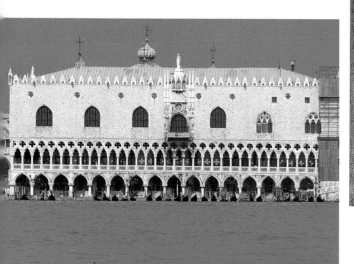

■ Gabriel Bella, *Interior of the Ducal Palace at the Beginning of the 18th Century*, Galleria Querini Stampalia, Venice. The triptych on the right wall could possibly be the *Crucifixion of St Julia*.

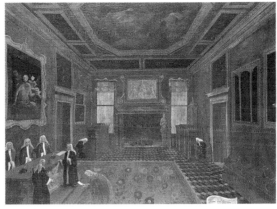

■ Bosch, *Altarpiece of the Hermits; St Anthony and St Aegidius*, c.1505, Palazzo Ducale, Venice. Here, Bosch uses deep and formal perspective for the landscape, although he does not dispense with his usual bizarre apparitions.

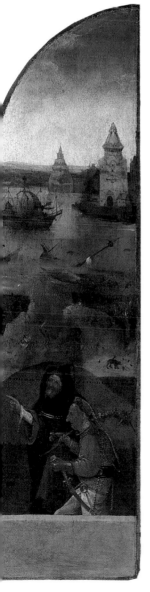

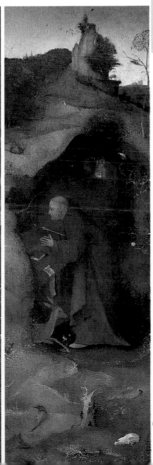

1500-1503

The Crucifixion of St Julia

Documented in 1771 by Zanetti as in the Ducal
Palace of Venice, this altarpiece, dating from
about 1500–4, was taken to Vienna in the 19th
century and then returned, badly damaged, to
its original location in about 1919.

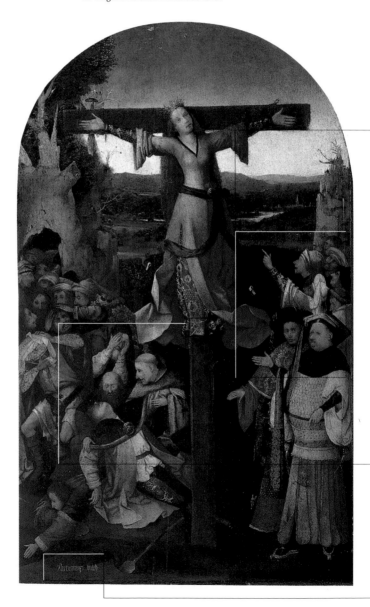

■ Unusually, the artist chose not to represent the isolated figure of a saint, but a scene of martyrdom in the presence of a crowd of spectators, dressed with headgear and clothing in the most diverse styles. The figures are arranged in the painting by means of a technique that is still medieval; they are not graduated in depth, according to the rules of perspective, but distributed on superimposed planes.

■ Whether the figure of St Julia was based on a real person or not is open to question. It has been suggested that it portays Liberata, daughter of the pagan king of Portugal who was crucified by order of her father, outraged by her desire to be the bride of Christ. However, the figure could be that of the St Juliana worshipped in northern Italy, who was sold by merchants to Eusebius. The young man fainting on the left could be one of the five thousand pagans converted by the girl.

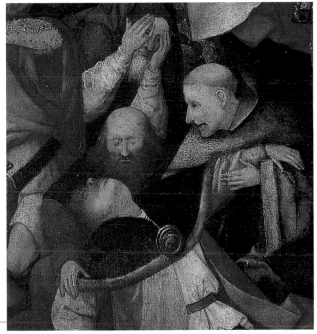

■ The signature of Bosch, in Gothic letters, prominent on the central panel, also appears in other triptychs, such as the *Hay Wain* and the *Epiphany*, both in the Museo del Prado in Madrid.

BACKGROUND

Bosch and early 16th-century Venetian painting

Traces of Bosch's possible stay in Venice could be seen in his formal and compositional innovations, dating from 1500–4. It is possible that his newly discovered inventiveness stemmed from the influence of some of the great artists in the Venetian tradition. The motifs of his hallucinatory fantasies met with particular success: his Venetian triptychs look forward, for example, both to the *Orpheus and Eurydice* (1508, Accademia Carrara, Bergamo) by the very young Titian, and to the uneasy tension of the *Martyrdom of the Ten Thousand* (1516, Gallerie dell'Accademia, Venice) by Carpaccio. Parallels are evident, too, in the work of Giorgione: his *Christ Bearing the Cross* (c.1510, Chiesa di San Rocco, Venice) seems to be a response to the style of introspection and the portrayal of physical deformity, so typical of Bosch. The disturbing visions of the northern artist found even wider popularity with the advent of the production of large numbers of engravings: it was in Venice, around 1508, that the Bolognese artist Marcantonio Raimondi engraved the famous *Dream of Raphael*, in which the influence of Bosch's monstrous creatures was unmistakable.

■ Giorgione, *The Three Philosophers*, c.1504, Kunsthistorisches Museum, Vienna. The great Venetian innovator also came under the influence of Bosch.

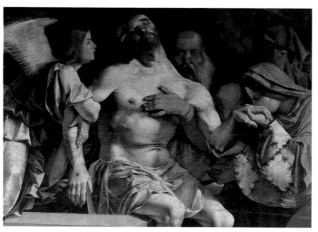

■ Lorenzo Lotto, *Recanati Poliptych, Pietà*, 1508, Pinacoteca Comunale, Recanati (Macerata). In the bearded face of Joseph of Arimathea are hints of the introspection typical of Bosch.

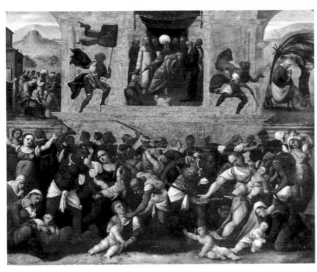

■ Lodovico Mazzolino, *Massacre of the Innocents*, 1548, Rijksmuseum, Amsterdam. Alongside elements that owe much to Raphael, the artist from Ferrara is responsive to anti-classical trends and to northern European practices, ranging from Dürer to Schongauer. The agitated rhythm also suggests the influence of Bosch.

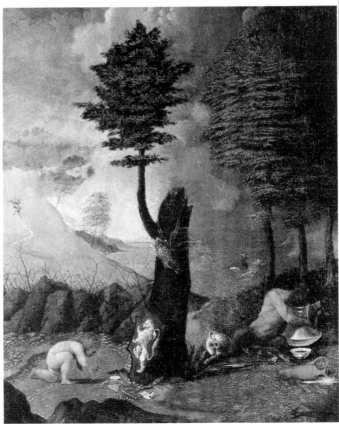

■ Lorenzo Lotto, *Allegory*, 1505, National Gallery of Art, Washington. From the beginning of his artistic career, Lotto showed his receptivity to the example of northern European painting, especially Dürer. Typical of this tendency is this allegory painted on the cover of the *Portrait of Bishop Bernardo de' Rossi* (1505, Museo e Gallerie di Capodimonte, Naples).There are traces of the Venetian tradition in his work, but this portrayal of landscape and figures is reminiscent of northern painting.

"Northern" Venice

Venice, at the beginning of the 16th century, boasted a flourishing range of artistic activity which was newly receptive to the influence of foreign cultures. The wealth of color, the expressive intensity, and the sharp profusion of detail were among the specific elements characteristic of northern European artists which now captured the attention of Venetian artists and collectors alike. Cardinal Griani, for example, possessed paintings by Bosch, Patinir, and Memling; the engravings and drawings of Cranach, Altdorfer, Schongauer, and Dürer were also widely circulated. All these works were acquired directly from the north or entered Venice by private routes, given the current prohibition of imports of foreign painted merchandise. The popularity of the northern style was increased after personal visits by the likes of Dürer, who exerted a profound influence on Venetian painting. Venice's relationship with northern art, which accentuated an anti-classical bias, spread rapidly throughout the north of Italy, reaching Bologna and Ferrara, where Amico Aspertini (1474–1552) and Lodovico Mazzolino (active c.1530) promoted these new influences.

■ Vittore Carpaccio, *Martyrdom of the Ten Thousand*, 1516, Gallerie dell'Accademia, Venice. Precise references to the *Visions of the Hereafter* by Bosch (1500–4, Palazzo Ducale, Venice) and echoes of Dürer.

■ Venice amid lagoon and mountains, engraving by H. Schedel from *Liber Chronicarum* 1493, Nuremburg.

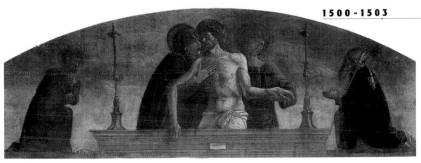

■ Giovanni Bellini, *Lament for the Dead Christ*, c.1472, Palazzo Ducale, Venice. The shape of the scene and the extreme sentimentalism of the figure of Christ reveal northern influences.

■ There are several paintings by Bosch in the Ducal Palace of Venice.

■ Albrecht Dürer, *The Feast of the Rose Garlands*, 1506, Narodnì Galerie, Prague. The painting shows the influence of Giovanni Bellini, and the individual details of the faces is typical of northern culture.

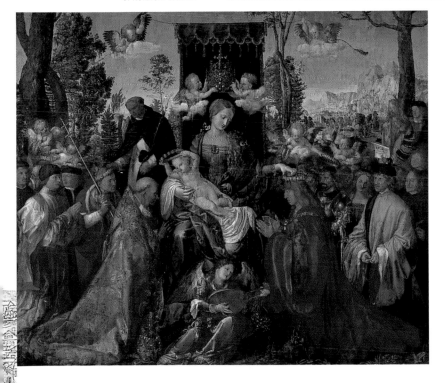

Bosch and Dürer:
a possible encounter

If Bosch visited Venice, he may have met the great Albrecht Dürer, who visited the city more than once. Even if there is no evidence of a personal meeting, it is reasonably certain that both men had the opportunity to see each other's works. Bosch represented the long, historical tradition of popular folk culture, suggesting simultaneously irony and piety, tangible yet surreal; Dürer, for his part, was preoccupied with the search for an intellectual balance between the overflowing luxuriance of nature and the dictates of classical perfection. Expressing themselves differently, but complementing each other in an identical feeling of disquiet (shortly to find an outlet in the Protestant Reformation), Bosch and Dürer give the impression of having exchanged ideas: Dürer explored further individual appearances and crowded some of his paintings with hundreds of figures, whereas Bosch, in contrast, gained increasing confidence in his depiction of nudes, and greatly expanded his range of subjects.

■ Albrecht Dürer, *Christ among the Doctors*, 1506, Thyssen Collection, Madrid. The faces of the scholars around Christ are reminiscent of Bosch.

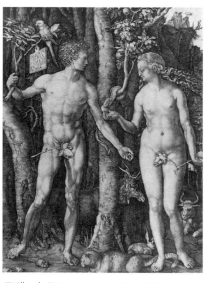

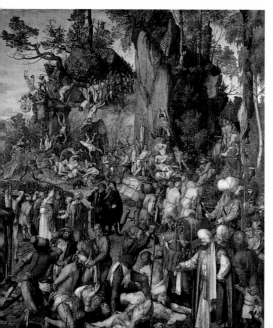

■ Albrecht Dürer, *The Martyrdom of the Ten Thousand*, 1508, Kunsthistorisches Museum, Vienna. Painted at the end of his journey to Venice, this work is stylistically similar to Bosch's.

■ Albrecht Dürer, *Adam and Eve*, 1504, engraving. The human bodies are balanced in classical proportions, but surrounded by symbolic animals, as in the Eden of Bosch reproduced on the right.

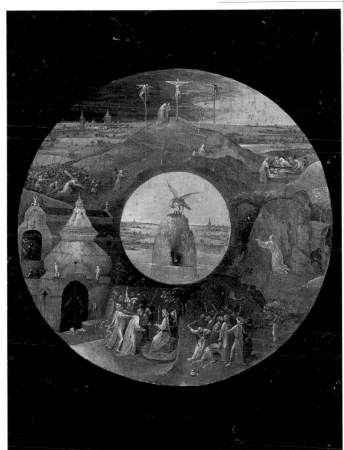

■ Bosch, *St John on Patmos*, reverse of a panel with *Scenes of the Passion*, 1504–5, Gemäldegalerie, Berlin. The refined grisaille technique, as well as the color, suggests analogies with the engravings of Dürer, an important source of iconographic motifs for artists throughout Europe. The lesser interest aroused by his earlier works is further confirmation of the alterations in style that Bosch made as a result of his time in Italy.

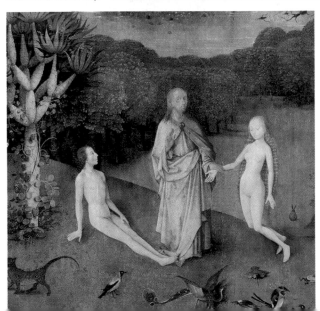

■ Bosch, *The Garden of Earthly Delights,* detail of the left-hand panel (1503–4, Museo del Prado, Madrid). The naked bodies of the first parents, even though still idealized in their representation, are an early sign of the artist's growing attention to anatomical truth.

1500-1503

St John the Baptist in the Wilderness

In a bright summer landscape, littered with symbols of evil, this painting (1504–5, Museo Lázaro Galdiano, Madrid) offers a rare example in Bosch's work of the victory over the temptations offered by the earthly world.

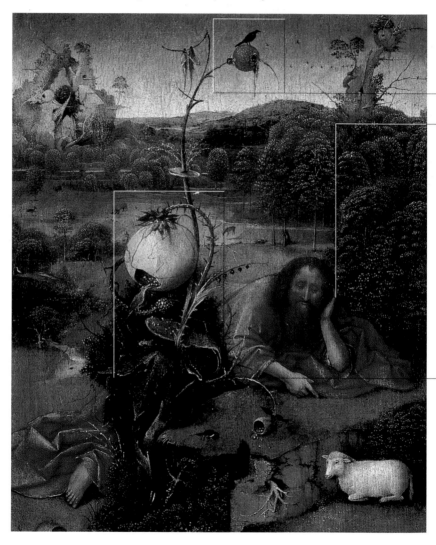

■ Various species of birds feed on wild berries: both the birds and the plant growths recall those of *The Garden of Earthly Delights* (1503–4, Museo del Prado, Madrid). Other similarities, like the oddly shaped rock in the background, suggest that the two paintings were completed at a similar time.

■ This clump of lush vegetation is in marked contrast to the fantastic character of the plant on the left, and with the rest of the landscape. The rocks in the background present an abstract, unnatural appearance. In comparison, the leaves of the shrubs are depicted here with considerable freshness and with sensitive brushstrokes giving a luminous effect.

■ A sinuous plant, bristling with thorns and with broad leaves, seems to divert the ascetic from his contemplative activity. It is a fantastic shrub, with disturbing fruits that allude to the temptations of earthly pleasures. The wild fruit, similar to a thistle, refers to the association of fruit with sin and punishment, learned by Man in the Garden of Eden. The bizarre vegetation, moreover, suggests that St John in the desert is having a hallucinatory vision.

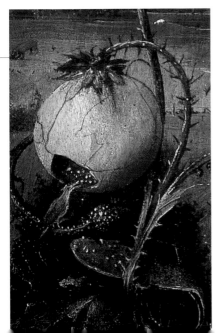

Expanding landscape

■ Joachim Patinir, *Landscape with Hunting Scenes*, c.1520, Musée d'Art et d'Histoire, Geneva. An attentive follower of Bosch, Patinir brings a monumental, heroic tone to his landcapes.

An almost obsessive dread of empty space characterizes the early works of Bosch: scenes swarming with figures, lacking any gradual transition from one plane to another, featuring a lofty background which leave visible only a thin strip of sky. After the turn of the century, changes begin to appear: Scenery and space open up, and substantially bigger forms often replace the indeterminate visions of the early triptychs, from the *St John on Patmos* (1504–5, Gemäldegalerie, Berlin)to the triptych of *the Adoration of the Magi* (1510, Museo del Prado, Madrid). At a time when the new geographical discoveries were stimulating a curiosity for natural phenomena, Bosch resumed his links with the Flemish landscape tradition of the 15th century and acknowledged the influence of Dürer's poetic naturalism. He also allowed his work to be enveloped by atmosphere, experimenting with the contrasts and blends of planes of pure color.

■ Albrecht Dürer, *Adoration of the Most Holy Trinity*, 1511, Kunsthistorisches Museum, Vienna. The landscape is a partial view of Lake Garda.

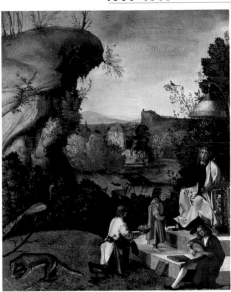

■ Lorenzo Lotto, *Assumption*, detail, 1506, Duomo, Asolo. The landscape has affinities with Dürer.

■ Bosch, *St John on Patmos*, detail, 1504–5, Gemäldegalerie, Berlin. There are echoes of Giorgione's painting in the delicately pure tones and the haze which enshrouds the idyllic countryside.

■ Giorgione, *Homage to a Poet*, c.1495, National Gallery, London. In this enigmatic painting, a protruding rock functions as a border to a much more expansive landscape, built up with rich colors.

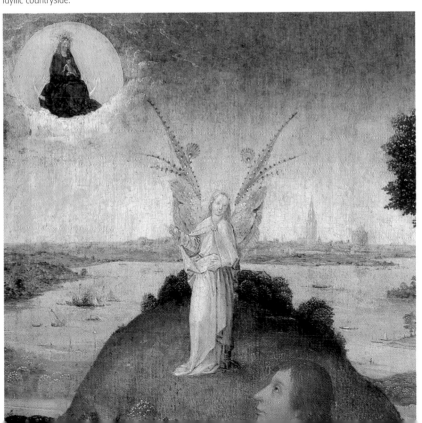

79

Preachers, mystics, and visionaries

■ Bosch, *St Christopher*, 1504–5, Boymans-Van Beuningen Museum, Rotterdam. Between 1498 and 1510 an altar in the chapel of St Anne in 's Hertogenbosch was dedicated to the widespread cult of this saint. Bosch's panel was probably an original part of it.

Incessant temptation, exaltation of the contemplative life, and absorption with the divine were recurrent themes in the troubled religious sensibility of the late Medieval period, and such concerns were fully explored and interpreted by Bosch. Among the principal exponents of these notions were the 14th-century monk Jan Ruysbroeck and the phil-osophy of Gioacchino da Flore, a 12th-century mystic. The imaginative were regaled by preachers and visionaries with fanciful evocations of the atrocious torments of hell, and emotionally roused to their devotional duties. These ideas were also successfully developed by the founders of the *Devotio Moderna* sect and the Brethren of the Common Life.

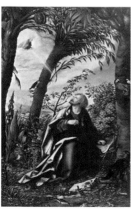

■ Hans Burgkmair, *St John the Baptist on Patmos,* 1518, Alte Pinakothek, Munich. The dramatic tension and natural description in this work by the German painter and engraver translate the ideas of the "Danube School" in the genuine spirit of the Renaissance.

■ Bosch, *St John on Patmos*, 1504–5, Gemäldegalerie, Berlin. Probably the lateral panel of a lost triptych, it was the first of the artist's "meditative" paintings: the saint's example is proposed as the only path to eternal salvation. According to the account of the Apocalypse, an angelic vision appeared to the saint while he was writing his own work, pointing him to the Virgin herself. The demonic creature at the bottom, with the thoughtful face of a bespectacled man, the tail of a scorpion, and pointed wings, is hard to interpret. On the reverse there is the elegant grisaille painting *Scenes of the Passion of Christ* (see p. 75).

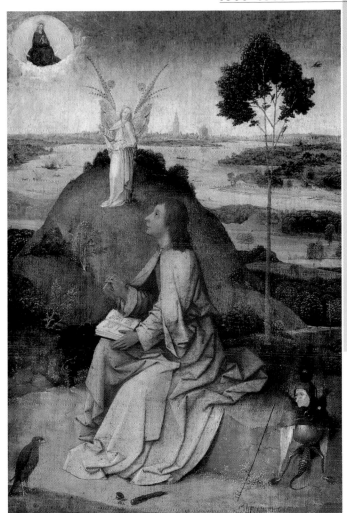

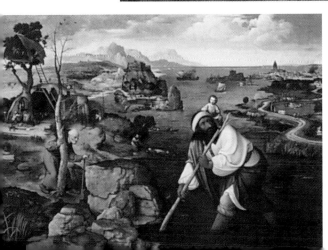

■ Joachim Patinir, *St Christopher*, c.1515 , Escorial, Madrid. St Christopher was a saint venerated at the end of the Medieval age as one of the Fourteen Holy Helpers: these, according to popular belief, saved anyone in peril who called on them. He was portrayed in the manner of a reassuring giant.

1500-1503

St Jerome at Prayer

The subject of the work is the exaltation of the contemplative life (c.1505, Musée des Beaux-Arts, Ghent): the saint is surrounded by an expanse of countryside; inside the cave, huge decomposing fruits allude to the temptations.

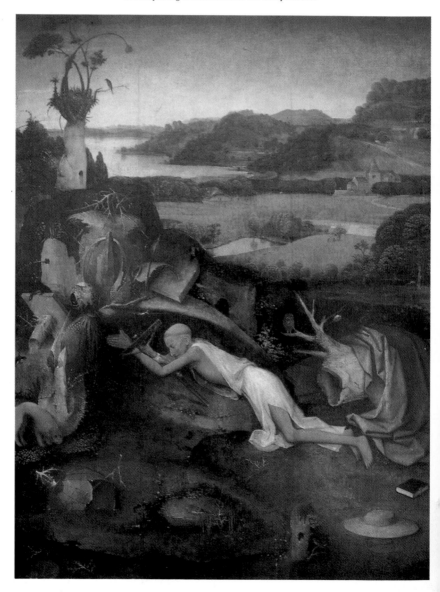

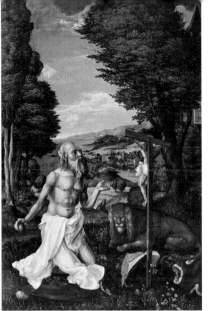

■ Hans Muelich, *St Jerome in a Landscape*, 1536, Alte Piinakothek, Munich. The most common form of iconography, with St Jerome kneeling before the crucifix, is of Italian origin: only around the end of the 15th and beginning of the 16th century did it reach northern Europe. An early example is a print by Dürer from 1496–97, to which this work by Muelich is linked.

■ Albrecht Dürer, *St Anthony before the City,* 1512, engraving. Dürer, the humanist, indicates the city as a possible place of meditation, without the necessity of being isolated.

■ Lorenzo Lotto, *St Jerome Penitent,* c.1510–20. Romanian National Museum of Art, Bucharest. As in the painting by Bosch, the saint is not represented on his knees but lying prone. The date is doubtful: the presence of the Castel sant'Angelo, in the background, suggests it was completed in about 1508–11.

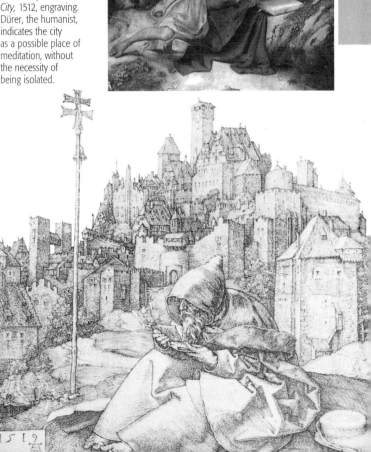

BACKGROUND

From Medieval autumn to Renaissance spring

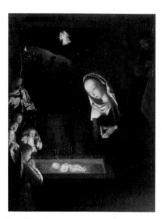

■ Geertgen tot Sint Jans, *Nativity*, c.1490, National Gallery, London. The emotional event, at night, is given emphasis by a beam of light.

The period that extends roughly from the discovery of America (1492) to the start of the Reformation (1520) is one of the most eventful and stimulating in European history. Artists and intellectuals, confronted by a world whose horizons, in the widest sense, were steadily expanding, searched for a new point of equilibrium: the serene certainties of humanism, based on the revival of classical civilization, suddenly appeared insufficient and unsatisfying, even in Italy, where the sensational rediscovery of the *Laocoon*, brought to Rome in 1506, conjured up a new, violent, dramatic image of antique art. North of the Alps, especially, the first few decades of the 16th century ushered in a brief Renaissance, in which the last manifestations of refined Gothic mingled with the equally cultivated expressions of Mannerism. Bosch, in his individual manner, defiantly combined the contradictions, the fears, and the new incentives of a fascinating age.

■ Bosch, *Crowning with Thorns*, detail, 1510, Escorial, Madrid. The grief of Christ is transformed into bitter awareness.

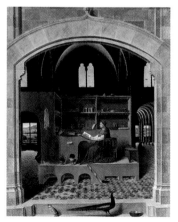

■ Antonello da Messina, *St Jerome*, c.1474, National Gallery, London. The study is a haven for knowledge.

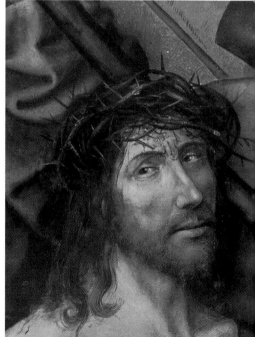

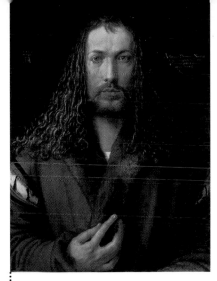

■ Bosch, *Altarpiece of the Hermits*, detail of *St Jerome*, c.1505, Palazzo Ducale, Venice. The myriad details in Bosch's paintings continually lend themselves to new interpretations, with their inexhaustible variety of classical allusions (the bas-relief with the centaur), mystical allegories (the crucifix leaning against the dry tree), excerpts from sacred history (the relief that depicts Judith and Holofernes), and episodes of popular vulgarity (the birds flying out of the backside of the man stuck in a barrel). Here, too, Bosch's figurative and cultural references appear more eclectic and diverse than ever, creating an expressive statement of rich originality.

Dürer and the awareness of the artist's role

The *Self-portrait* painted in 1500, in the Alte Pinakothek of Munich in Bavaria, demonstrates Dürer's sharp perception of himself as well as his immense ambition. At the start of a new century the figure of the artist reclaimed center stage as creator and interpreter. The hand of the painter must be guided by a penetrating intelligence and an active determination to become the protagonist of time and history. This approach marked a radical change in social status, as the artist was promoted from that of a specialized craftsman to that of poet, philosopher, and freethinker.

■ Bosch, *Triptych of the Hermits*, detail of *St Jerome*, c.1505, Palazzo Ducale, Venice. Recourse to alchemy, astrology and other mystical practices was an alternative to the laborious investigations required for mastering the exact sciences.

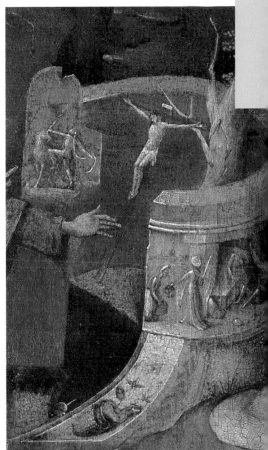

Paradise and Hell

These panels, now in the Ducal Palace of Venice, show the *Earthly Paradise*, the *Ascent to Heaven*, the *Fall of the Damned*, and *Hell*. Probably they constituted, in pairs, the wings of a lost triptych from 1500–4. However, the central element, a square panel, is missing.

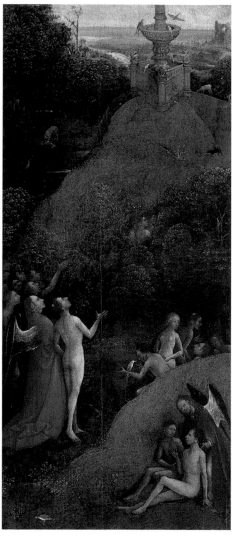

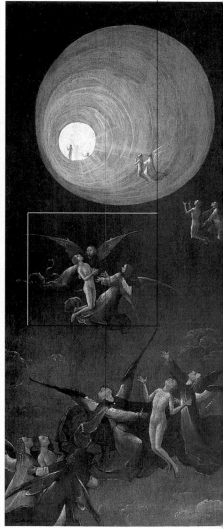

■ Following an
ascending path,
the souls destined
for beatitude are
accompanied by their
guardian angels toward
a cone of light which
rends the shadows.
These visionary images
may have been inspired
by the work of the
mystic Ruysbroeck.

Bosch, *The Temptation of St Anthony*, detail, 1510, Museo del Prado, Madrid

Bosch, Erasmus of Rotterdam, and madness

Bosch's period of profoundest reflection and finest painting corresponds to that which saw the development in the religious thinking of his great fellow countryman Erasmus of Rotterdam. The publication of the latter's *Adagia* (*Proverbs*) in 1500 mirrors Bosch's analogous immersion in folk culture, and the combination of fragments of wisdom, quotations, and good common sense reflects the detachment of a humanist steeped in classicism. In 1509 Erasmus published his *Elogium Insaniae* (*Eulogy on Madness*), in which, questioning the very fundamentals of his humanism, he expressed the need for a thorough rethinking. Denunciation of the vices of the clergy and the necessity for direct moral engagement connect Bosch and Erasmus just a few years before Luther's Reformation.

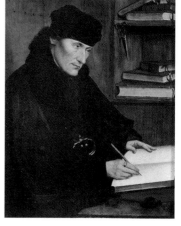

■ Quinten Metsys, *Erasmus of Rotterdam*, c.1515, Galleria Corsini, Rome. European intellectuals regarded Erasmus as a model of calm intelligence.

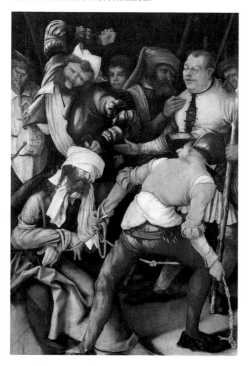

■ Mathias Grünewald, *Mocking of Christ*, 1504–5, Alte Pinakothek, Munich. The pathetic image of Christ, vanquished and impotent before the crowd of persecutors, seems to represent the harsh situation of the true Christian at the beginning of the 16th century, subjected to doubts, provocations, and tensions.

■ Bosch, *The Seven Deadly Sins*, detail of *Wrath*, 1475–80, Museo del Prado, Madrid. Bosch repeatedly presented images of the dehumanizing effects of discord and violence. These concepts were echoed by the "moderate" intellectuals engaged in religious debate in different areas, such as Erasmus, Dürer, and Melantone, who feared the grave consequences of strife for European civilization. Indeed, after the schism brought about by Luther, the continent was to be ravaged by the terrible wars of religion.

■ Bosch, *The Hay Wain* Triptych, detail of the central panel, c.1500, Museo del Prado, Madrid. Bosch's savage, surreal, deforming brand of pessimism portrays the same moral and ethical tensions that Erasmus analyzed, albeit in more dignified and erudite terms through the filter of humanist culture.

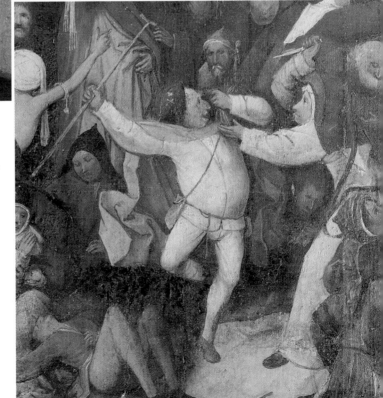

Alchemy: metamorphosis of matter

Ranked by the thinkers of the Enlightenment as one of the "false" as against "exact" sciences, alchemy, traditionally born in China in the fifth millennium BC, appeared as a fanciful version, both in its assumptions and results, of chemistry. At its basis were certain concepts of occult philosophy: the creative principle, known as the universal spirit, could be extracted from the fusion of nature and matter for beneficial and profitable purposes. The ultimate goal of the alchemists was to discover the secret formula necessary to obtain the philosopher's stone, or spiritual illumination. The spirit thus extracted was then to be directed toward the different realms of matter, so bringing about complex processes of transmutation which, in gradual stages, would change the darkness of lead into the light of gold. The site of these transformations was the alchemist's laboratory in which was located the inevitable furnace, the place where the actual procedures were performed. Exchange of formulas among alchemists involved the use of a special language, consisting of an intricate system of signs, and these were to exercise their fascination on artists of every age.

■ This 17th-century engraving is a portrait of Theophrastus of Hohenheim, better known by his surname Paracelsus. This Swiss alchemist lived from 1493 to 1541: here he is holding a jar of nitrogen, which in alchemy corresponded to mercury.

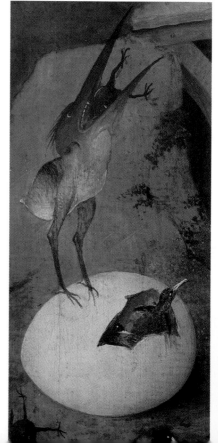

■ Albrecht Dürer, *Melancholy I*, 1514, Musée du Louvre, Paris. The title refers to "melanosis" or black bile, the first state of matter, corresponding to the "humor" of melancholy.

■ Bosch, *The Temptations of St Anthony*, detail, 1505–6, Museu Nacional de Arte Antiga, Lisbon. The egg symbolizes the alchemist's crucible.

■ Giovanni Stradano, *The Alchemist*, 1570, Palazzo Vecchio, Florence, Study of Francesco I de' Medici. Even in the Florence of the Medici there was an interest in alchemy.

■ Bosch, *The Garden of Earthly Delights*, detail of the *Musicians' Hell*, 1503–4, Museo del Prado, Madrid. In alchemy, the hollow body of the tree-man is where matter is transtormed, while the black, white, and red colors allude to the stages of boiling mercury.

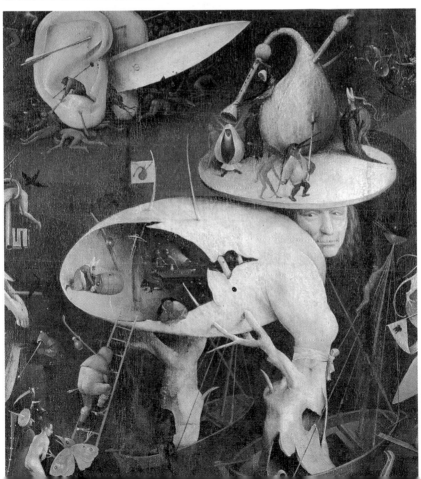

Followers, imitators, and copyists

■ Monogram artist JS, *Hell*, detail, c.1600, Palazzo Ducale, Venice. Those guilty of the sin of greed are depicted as obese, seated at a table, and forced to eat toads and reptiles.

Bosch may seem to be a unique artist, yet his style was adopted by a number of copyists, with a high measure of commercial success. Bosch himself made replicas of some of his works (there are two versions of the *Hay Wain*, for example, one in the Prado and one in the Escorial). Alongside the activities of his more slavish imitators, there appeared a few artists who drew inspiration from Bosch's paintings to produce independent and interesting compositions. Among these were Quinten Metsys and Joachim Patinir, some of whose paintings are reproduced in this book. While Metsys combined the moral tension of Bosch's half-length paintings with Flemish tradition, Patinir studied the backgrounds of the master's crowded fantasies and used them for his own grandiose landscape visions.

■ Antwerp Master, *Temptation of St Anthony*, c.1545, Museo Corre, Venice. Italianate colors are combined with echoes of Bosch.

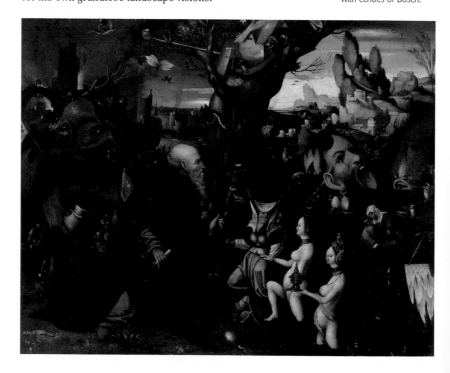

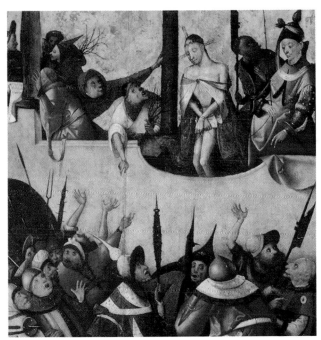

■ Imitator of Bosch, *Ecce Homo*, 1500–4, Museum of Art, Philadelphia. The work was long attributed to Bosch himself, whereas today it appears to be that of a direct follower, stylistically more fragile, but otherwise faithful to his master's vision. It is one of the earliest "imitations" of Bosch, testifying to his rapidly increasing popularity and marketability.

■ Quinten Metsys, *Ecce Homo*, 1526, Palazzo Ducale, Venice. Metsys journeyed to Italy, and in particular to Venice, in the very early 1500s. Although he did not paint grotesques or crowded scenes, the Antwerp painter seems to have had repeated contact with Bosch. As this painting demonstrates, Metsys, too, portrayed the contrast of good and evil as "beautiful" and "ugly". It is interesting to note how the fresco discovered in the Milanese abbey of Chiaraville (see pp. 58–59) has been as frequently attributed to Bosch as to Metsys.

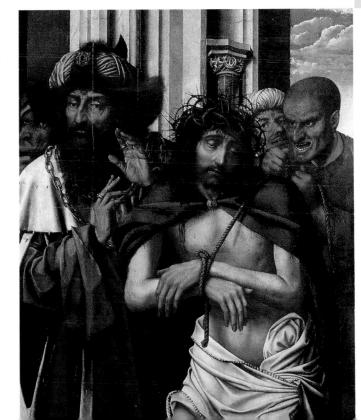

BACKGROUND

The Last Judgment: Medieval to Renaissance

■ Rogier van der Weyden, *Poliptych of the Last Judgment*, central panel, 1445–50, Hôtel-Dieu, Beaune. In the center the Archangel Michael weighs the souls of the blessed.

The dramatically striking theme of the Last Judgment is frequently treated in European Medieval art. It appears on the carved tympani of Romanesque cathedrals, in Gothic marble reliefs, and in monumental 14th-century paintings. It later developed in the 15th and 16th centuries, when the spectator seems to become ever more directly and actively involved, culminating in Michelangelo's uniquely powerful version on the wall of the Sistine Chapel in the Vatican. Bosch inherited the 15th-century Flemish and German tradition, reproducing the image of Christ the Judge seated on the rainbow, and adopting a similar compositional structure. In contrast to his predecessors, however, Bosch used his far-ranging imagination to depict torments, tortures, bizarre instruments of execution, fantastic shapes of infernal buildings, and monstrous figures of demons. Amid this cluttered, irreverent chaos of Hell, the sober, austere symmetry that characterized earlier images is turned on its head: at the most solemn and most definitive moment of Christ's victory, Bosch cannot resist dramatically portraying the incontrovertible triumph of evil.

■ Stephan Lochner, *Last Judgment*, c.1440 , Wallraf-Richartz-Museum, Cologne. The gesture of Christ seems to divide the kingdom of Heaven (on the right, with the Gothic entrance portal to Paradise) and the darkness of Hell, toward which the snarling devils drag the sinners.

■ Bosch, *The Last Judgment*, detail, 1475–80, Museo del Prado, Madrid. The precise subject of this scene is the resurrection of the flesh. The dead, before being subjected to divine judgment, emerge from their tombs and confront one another on a featureless and barren patch of ground.

■ Bosch, *The Last Judgment*, detail of *Hell*, 1506–8, Groeninge Museum, Bruges. Every hell scene painted by Bosch contains a variety of themes and objects: in *The Garden of Earthly Delights* Hell contains sophisticated musical torments; in the Vienna version, however, the emphasis is on the devilish kitchen and metallic implements. Everyday objects appear in the small triptych from Bruges, growing to enormous dimensions and transformed into machines of torture.

1504-1516

The Last Judgment

Shown here is the central panel of *The Last Judgment* triptych (c.1504, Academy of Fine Arts, Vienna): Original Sin and Hell appear on the lateral wings, while the outer faces depict St James of Compostela and Bavo of Ghent. The triptych may have been commissioned by the duke of Burgundy, Philip the Handsome.

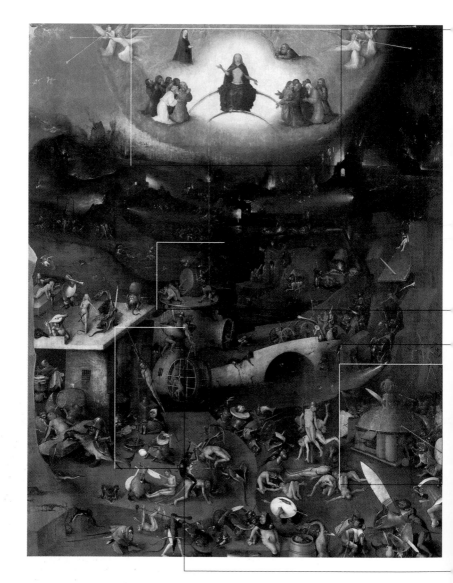

■ The small number of the chosen, compared with those condemned to the most atrocious punishments, reveals Bosch's pessimistic view. On either side of Christ the Judge, placed on soft clouds, are Mary and St John the Baptist.

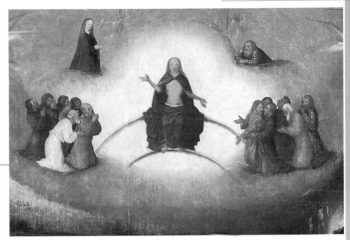

■ The extreme fantasy of the artist is evident in the depiction of the torments of sinners: a strange and complicated machine, set above a large overturned pitcher, consists of a wheel which is crushing several figures, and is being dragged around by men dressed only in black shoes. A small and acrobatic devil directs the operation.

■ The sins committed during life are punished with different torments, according to their degree of guilt: the sinners are hung from hooks like butchers' meat, are fried in the pan, and are roasted on the spit by monstrous females – hybrids of women and reptiles.

■ Blades, knives, and arrows that transfix the damned appear frequently in the representations of infernal punishments: the source is the biblical text in which Isaiah speaks of pointed arrows and drawn bows with which the sinners are afflicted at the Last Judgment. The knife, however, is regarded as a sexual symbol.

Artistic developments in Holland and Flanders

During the first two decades of the 16th century there was an important turning point in Flemish-Dutch art. The final years of the last generation of great masters in the 15th-century tradition left room for a strong current of revival, based mainly on an updated interpretation of Italian art innovations. Some painters, like Metsys, Mabuse, and Van Scorel, made study trips to Venice and Rome, familiarizing themselves with the monumental and synthetic classical style that contrasted with the minutely realistic legacy of northern painting. The great harbour city of Antwerp emerged as the principal cultural center of the Low Countries, usurping the places of Bruges and Ghent. Jan van Scorel, one of the most authentic Dutch painters (although the term, it should be remembered, was still an anachronism) was given his opportunity after 1520, with the election of Pope Hadrian VI; he was offered the task of curating the antiquities of the Vatican, a prestigious role previously entrusted to Raphael. This provided a definitive stimulus for Flemish-Dutch painters to adopt the formal models of Italian Mannerism.

■ Lucas van Leyden, *Madonna and Six Angels*, c.1520, Gemäldegalerie, Berlin. The link with Dürer suggests the influence of Venetian painting.

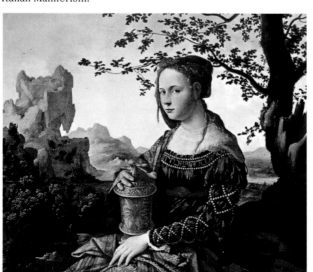

■ Jan van Scorel, *The Magdalen*, c.1528, Rijksmuseum, Amsterdam. The first and most important of the "Italianists" creates compositions with plenty of space.

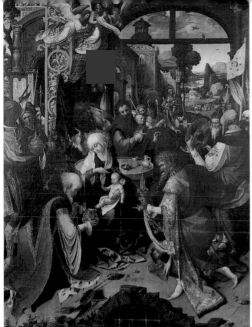

■ Bernard van Orley, *Holy Family*, 1522, Museo del Prado, Madrid. Tuscan motifs of the Renaissance are rendered with bright colors and an impeccable sense of design.

■ Jan de Beer, *Triptych of the Adoration of the Magi*, central panel, c.1510, Pinacoteca di Brera, Milan. This bizarre painting, which fused the Flemish miniaturist style with more modern allusions to the architecture and compositional rhythms of the Italian Renaissance, was painted by the Antwerp artist in Venice.

■ Master of the Half-length Female Figures, *Portrait of a Girl Writing*, c.1510, Czartorysky Museum, Cracow. As this delicate painting implies, the Flemish tradition did not collapse under the weight of Italian influence; observation of reality and feeling would flourish anew in the great school of 17th-century Dutch painting.

101

Reality and fantasy: art in the Low Countries

The 16th century, with its turbulent political and religious changes, and swift succession of geographical discoveries, wars, and economic revolutions, provoked wide-ranging reflection on questions of form and meaning in the world of art. In the Low Countries, directly opposed schools of thought explored the paths of realism and imagination. The painting of Bosch exemplified both trends. At first glance, his seething compositions appear to celebrate the liberating, creative surge of fantasy, in aspects that are frequently bizarre and perplexing; yet closer inspection reveals his faithful adherence to detail in domestic scenes and unpretentious everyday surroundings. Partly in reaction against the protracted Italian influence of the Renaissance and Mannerist periods, 16th-century Dutch-Flemish art sought to recover a more realistic style, but in a wholly new guise. With the advent of Calvinism, and the consequent drying up of religious commissions, Dutch art was henceforth directed more toward the private collector, in the form of genre, landscape, still life, and portrait painting.

■ Pieter Artsen, *Adoration of the Shepherds* (fragment), c.1550, City Museum, Amsterdam. The figure of a shepherd and the head of a cow are all that remains of a large altarpiece in Amsterdam's Nieuwe Kirke, destroyed by iconoclasts in 1566; with the arrival of Calvinism in Holland, sacred painting virtually disappeared.

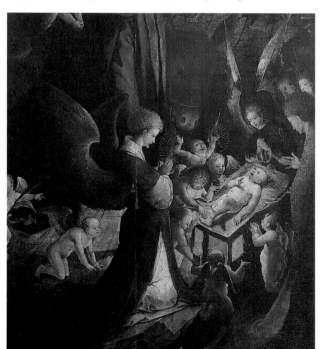

■ Jan de Beer, *Triptych of the Adoration of the Magi*, panel with the *Nativity*, detail, c.1510, Pinacoteca di Brera, Milan. The "nocturne" has always been a much loved genre in the Low Countries: this special type of softly-lit and personal situation was to be strongly developed in the course of the 17th century.

■ Quinten Metsys, *Diptych of Christ the Saviour of the World, The Virgin at Prayer* , c.1500, Musées Royaux des Beaux-Arts, Antwerp.

■ Quinten Metsys, *Temptation of St Anthony*, c.1520, Museo del Prado, Madrid. Here Metsys incorporates elements of fantasy into his work.

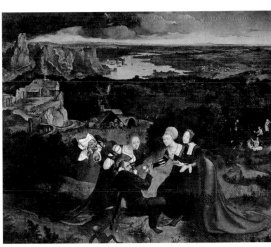

■ Bosch, *The Seven Deadly Sins*, detail of *Gluttony*, 1475–80, Museo del Prado, Madrid. Bosch was a pioneer of genre scenes, with his moral episodes from everyday life.

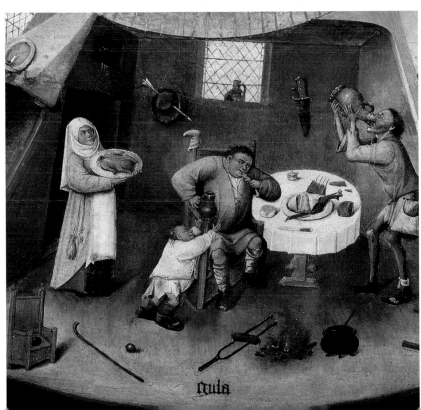

Half-length paintings

Around 1510 the painting of Bosch took an unforeseeable turn. The crowded scenes, teeming with people and innumerable fantastic apparitions, were now replaced by a diversity of images, arranged in groups of comparatively few figures, set in the foreground and therefore in larger dimensions. Bosch had already carried out some experiments in this style, as in the *Ascent of Calvary* in Ghent, but in this final phase of activity his half-length figure paintings, as viewed looking upward from

below, became much more frequent. This must certainly have been a reflection of the period spent in Italy, and especially his trip to Venice and parallel experience of Dürer: indeed, this unusual form of composition was subsequently developed, after the mid-15th century, by Mantegna and continued by Giovanni Bellini. It was to meet with wide commercial success throughout the 16th century.

■ Dosso Dossi, *Concert*, c.1525, Galleria Palatina, Florence. In the course of 16th-century art, the compositional scheme with half-length figures was adopted primarily for paintings of secular subjects.

■ Giovanni Bellini, *Pietà*, c.1465, Pinacoteca di Brera, Milan. Taking the example of Mantegna as departure point, Giovanni Bellini places the three dramatic figures behind a marble parapet.

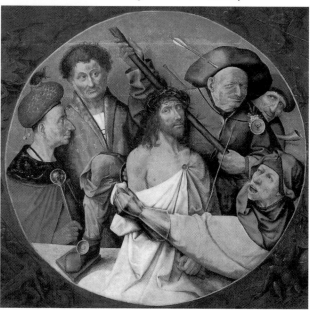

■ Bosch, *Crowning with Thorns*, 1510, Escorial, Madrid. This is a highly dramatic and concentrated version of the mocking of Christ theme. Bosch complicates the structure, introducing a circle inside the quadrangular shape of the table, and playing with an asymmetrical composition of the groups of figures around Christ.

■ Bosch, *Adoration of the Shepherds*, c.1510, Wallraf-Richartz Museum, Cologne. A work of debated attribution but full of fascination, testifying to the development of Bosch's art, here reducing the number of figures and magnifying the sizes, in the interests of depth. This is reflected in the overt smile of the shepherd in the background and the effective "portraits" of the ass and the cows.

■ Giovanni Bellini, *Presentation of Jesus in the Temple*, 1460–64, Galleria Querini Stampalia, Venice.

Christ Crowned with Thorns

Dating from 1508-9, this painting, in the National Gallery of London, represents a moment of meditation on the passion of Christ, according to Bosch's interpretation of the doctrine of *Imitatio Christi*.

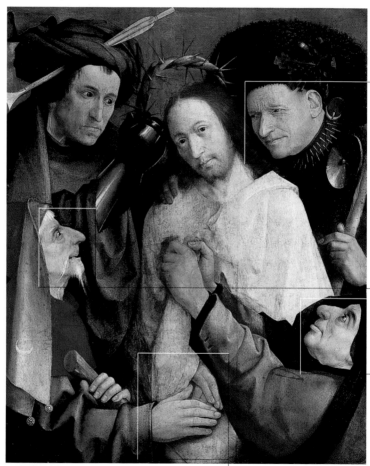

■ The fine details of Bosch's paintings are evident here, displaying a skill that contrasts with his earlier work, which was more Gothic in style.

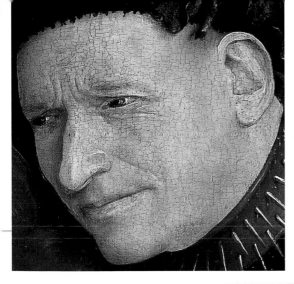

■ The attributes of the executioner are difficult to interpret, notably the oak leaves on the hat and the broad collar studded with spikes. The latter appears to be the type of collar used for dogs, which might allude to the lack of individuality and willpower of the character, but its true meaning is still unclear.

■ In his mature works, Bosch tends to devote himself to compositions with few characters depicted half-length, thus allowing him to concentrate on the psychological features of the figures concerned. The onlookers, in fact, provide a complete cross-section of the various grades of evil, which reaches culmination in the satanic leer of the old man with the beard. Comparison with the Ghent *Ascent to Calvary* (pp.64–65) clearly demonstrates his development of style and compositional skill.

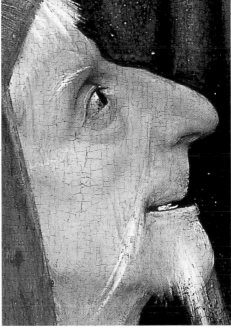

■ The malevolent faces of the onlookers have been interpreted as references to the four temperaments: the figures at the top may allude to the phlegmatic and the melancholy, and the lower ones to the sanguine and choleric temperaments. In any case, there is a sharp contrast with the gentle face of Christ and a serene acceptance of grief.

Destruction by fire

Cities devastated by fire, towers in flames, and gigantic conflagrations that create spectacular effects in sinister infernal landscapes constitute an emblematic motif of Bosch's art, ranging from one of his early roundels, *The Seven Deadly Sins* (1475–80, Prado, Madrid) to his last works. The development of the fire motif is associated with a significant event in the artist's memory: on June 13, 1463 a fire reduced the town of 's Hertogenbosch to ashes, leaving an indelible impression on his mind. It was an experience that was later to be incorporated in Bosch's visions of the infernal fiery torments that await humanity heedless of divine law. The obvious literary source was the biblical episode of God's destruction of Sodom and Gomorrah, repositories of perversion, and subjected to an incessant rain of fire and sulphur. The combining of the native and biblical cities implies unsparing criticism of corrupt contemporary society. The motif of fire was the centerpiece of many later works by different artists: the flaming bolts from the night sky depicted by Lucas van Leyden in *Lot and His Daughters* (Louvre, Paris; see p. 28) are reminiscent of Bosch.

■ Top, Bosch, *The Garden of Earthly Delights*, detail. 1503–4, Museo del Prado, Madrid.

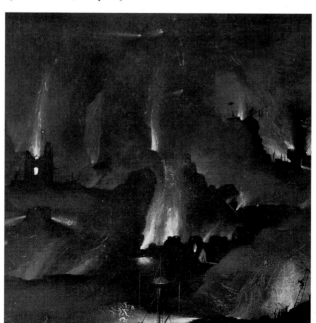

■ Above, Bosch, *Visions of the Hereafter*, detail of *Hell*, 1500–4, Palazzo Ducale, Venice.

■ Left, Bosch, *Triptych of the Last Judgment*, detail of *Hell*, c.1504, Academy of Fine Arts, Vienna.

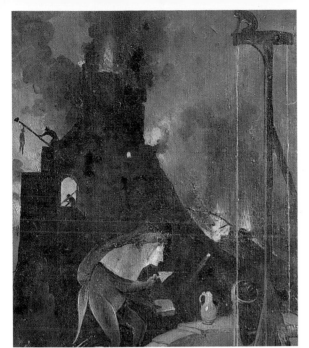

■ Bosch, *Hay Wain Triptych*, detail of the *Infernal Constructions*, c.1500, Museo del Prado, Madrid. The glare of the fiery sky behind the towers allows the artist free play with effects of back lighting.

■ Bosch, *The Temptation of St Anthony*, detail, 1505–6, Museu Nacional de Arte Antiga, Lisbon. The fire alludes to the role of St Anthony as protector against the disease known as "St Anthony's Fire".

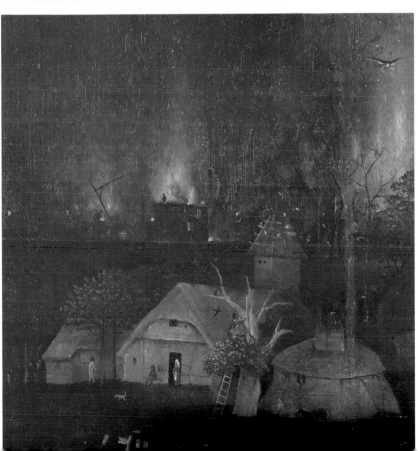

BACKGROUND

Temptation: a timeless theme

The principal source of knowledge about the life of St Anthony is the biography of his contemporary, Athanasius, who tells how in AD271 the 21-year-old Anthony retired into the desert to live as an ascetic. In the late Medieval age the key episodes of his life became known through the *Golden Legend*, a collection of saints' biographies by Jacob of Varagine. In particular, the iconography associated with the temptations of Anthony was established: it contrasted two types of torment – the aerial, which portrayed the saint carried off to heaven by demons, and the earthly, which featured seductive apparitions sent to tempt the hermit. In 1478 the publication of the Netherlandish version of the *Golden Legend* gained the subject widespread local popularity: the figure of St Anthony seemed to conform closely to the sensibility and the moral climate of the age. Innumerable paintings were devoted to the temptations: Bosch alone produced eleven versions of the episode.

■ Jan de Cock, *Temptations of St Anthony*, Thyssen Collection, Madrid. The Leyden painter's version is both sinister and demonic.

■ The aerial torment of St Anthony, in an engraving by Albrecht Altdorfer.

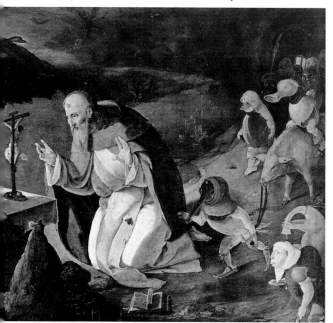

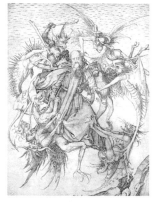

■ Lucas van Leyden, *Temptations of St Anthony*, c.1530, Musées Royaux des Beaux-Arts, Brussels. The devils with long, funnel-shaped noses are taken from Bosch.

■ Savoldo, *Temptations of St Anthony Abbot*, 1515–20, Timken Art Gallery, San Diego. This shows clear echoes of Bosch's Venetian triptychs.

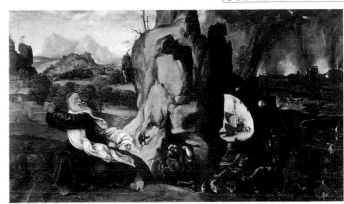

■ Bosch, *Temptation of St Anthony*, 1510, Museo del Prado, Madrid. The strange creatures such as the small demons do not seem to disturb the saint's meditation.

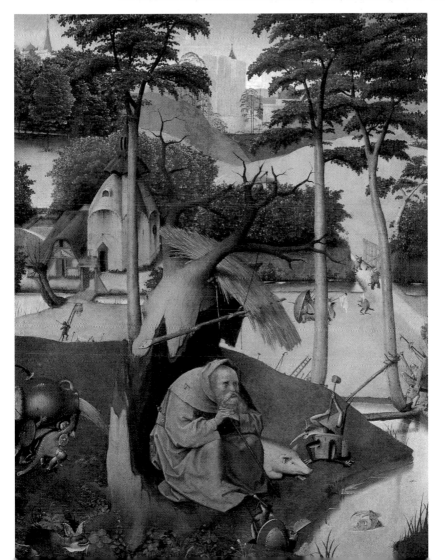

Temptation of St Anthony

Now in the Museo Nacional de Arte Antiga of Lisbon, the triptych of *The Temptation of St Anthony*, the central panel illustrated here, was perhaps acquired in 1523 by the Portuguese humanist Damiao de Gois, but is dated 1505–6.

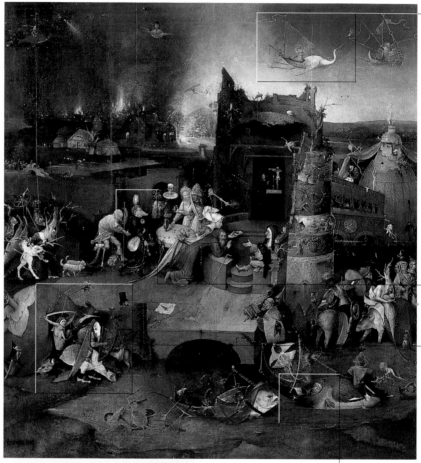

■ Curious beasts swim in the river: a headless duck moves along with a devilish character wearing spectacles trapped inside its body.

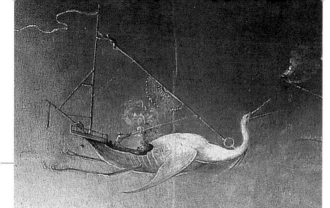

■ Nothing is real or probable in the scene, the mood being established with the fantastic flying boats in the sky. In this case a white bird has been transformed into an actual ship with wings: The designs on jewels and coins of the age of Alexander seem to have stimulated Bosch's fantasies.

■ A crowd of very mixed characters surrounds the central episode which features priestesses in elegant robes celebrating a profane Mass: an old, infirm man advances to receive communion, a musician carries a mandolin, dressed in a black cloak, with the face of a pig and an owl on his head, symbolizing heresy.

■ Out of an enormous red fruit, an allusion to the alchemist's crucible, emerge a group of monstrous figures led by a devil playing a harp, an evident profanation of the angelic instrument. The bearded man with the top hat, leaning against the wall in the background, may be interpreted as a magician who is conducting and orchestrating the entire composition. The creature which the diabolical artist is astride is also highly ambiguous: it appears to be a strange animal inserted inside the skin of a huge plucked bird. On its feet it wears a pair of clogs.

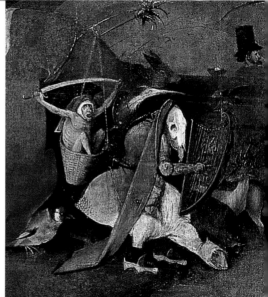

1504-1516

Flight and fall of St Anthony

The saint, supported by companions after his fall from heaven is the protagonist of the left-hand panel of the triptych of *The Temptation of St Anthony*, according to the narratives in the biography of Athanasius and the *Golden Legend*.

■ St Anthony, his hands joined as a sign of his indestructible faith, is carried into the sky by winged demons. He is accompanied by Bosch's familiar motifs of fish, lizards, and other strange composite creatures. The saint is however heedless of his tormentors.

■ Real and fantastic elements merge in the landscape: thus the hill is formed from the back of a man crawling on all-fours, covered with a grassy cloak. His rear serves as the entrance to what some have interpreted as the saint's retreat and others as a brothel. It is a clear reference to the sin of sodomy.

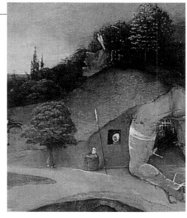

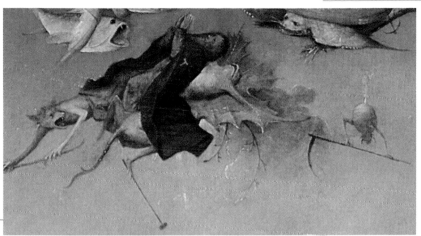

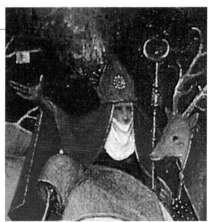

■ The group of demonic figures are evidently a parody of a holy procession, led by a devil who wears a mitre and carries a staff. The deer in the red cloak with him is generally a Christian symbol of the incorruptibility of the soul, but is here employed for the opposite effect.

■ Underneath the bridge that crosses the frozen pool, an infernal group crouch to listen to a monk who reads from a letter. The scene, taken in conjunction with the bird on skates which is bringing a lewd written message, is an allusion to those members of the clergy who enrich themselves by the selling of indulgences.

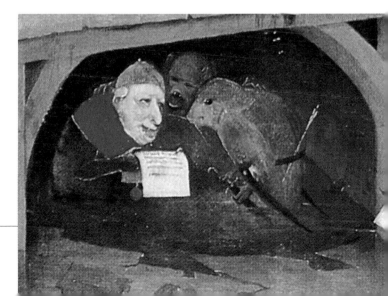

1504-1516

Meditation of St Anthony

Against the background of a turreted city, the saint, heedless of the temptations offered by his visions, is shown as champion of the faith, victorious over the forces of evil. This is the subject of the right-hand panel of the triptych of *The Temptation of St Anthony.*

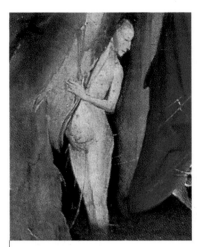

■ The naked woman who peeps from the curtain is the disguised demon figure of a queen encountered by the saint, according to the story in the *Vitae patrum*. The hollow tree is yet another reference to the alchemical symbolism present in the whole triptych.

■ There are numerous references to witchcraft and black Masses among the episodes associated with the saint, seen here in the central panel. Here two figures are flying on the back of a fish, according to the belief that diabolical assistance lent witches the ability to fly to the place where their gatherings were held.

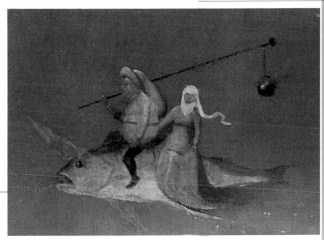

■ Among the unusual figures populating the scene is a small, gnomelike figure, wrapped in a red cloak that leaves only his eyes and hooked nose visible. He is barefoot inside a walking frame and has a toy windmill attached to his head. Both objects, walker and windmill, are similarly depicted in the *Child at Play* (1490-1500), the reverse side of the *Ascent to Calvary*, Kunsthistorisches Museum, Vienna (see p. 126), alluding to human irresponsibility, with reference not only to the innocent years of childhood, as in the Vienna painting, but also to life in its entirety.

■ The laid table, held up by naked demons, is a reference to the final temptation to which the saint was subjected, namely gluttony. The bread and the jug on the table are also an allusion to a Eucharist celebration of a sacrilegious nature – confirmed by the pig's trotter that is sticking out of the jug.

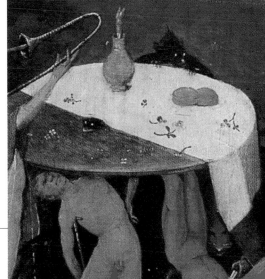

BACKGROUND

Winds of reform

The second decade of the 16th century marked a crucial moment in the history of modern Europe. Within a few years, politics and religion were shaken to their roots. The phenomenon of greatest relevance was the wave of resentment against the Catholic church, especially in its selling of indulgences, which eventually carried over to the Lutheran Reformation. The critical, and then overtly schismatic, pronouncements of the German monk found support in a vast revolution of religious thought and belief which swept across Europe, and which certainly found a response in the works of Bosch. The moral calls (more or less explicit), the reiterated theme of the folly of mankind falling victim to sin and rushing toward infernal tortures, the total inadequacy of the clergy, intent only upon fleshly pleasures and wealth – these are his recurrent motifs. Such preoccupations, however, are by no means peculiar to Bosch, who was nearing the end of his life and pondering in his art issues that affect mankind. Although the methods and the results would seem not to bear comparison, these are the same problems that confront other great artists such as Leonardo, Dürer, and Grünewald. Their concern, too, is to ponder deeply on the role and destiny of mankind in the universe.

■ Bosch, *Triptych of the Temptations*, detail of the *Temptation of St Anthony*, 1505–6, Museu Nacional de Arte Antiga, Lisbon. Many specifics of this extremely important triptych can be seen as a savage satire on the clergy.

■ Hans Baldung Grien, *The Young Woman and the Devil*, 1510, Kunsthistorisches Museum, Vienna. The painter, a favorite pupil of Dürer and then active in Strasbourg, was one of the first artists openly to declare his adherence to the Reformation. Even in his youthful, identifiably "Catholic" works, there were frequent demands for the observance of strict morality.

■ The face of the young Luther in an early portrait by Lucas Cranach the Elder.

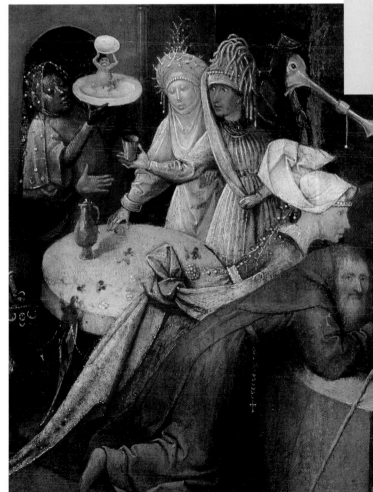

■ Bosch, *The Temptation of St Anthony*, detail, 1505–6, Museu Nacional de Arte Antiga, Lisbon. The celebration of the Black Mass, in the central panel of the triptych, is one of the most important and controversial details in the attempt to decipher the dense, contradictory spirit of the master.

The last works

Bosch's mature works are marked by open landscapes and simplified structures in which the themes are prevalently meditative or analytical. The productions of his final years, however, are conceived on two complementary levels. Works such as the *Last Judgment* of Munich (1506–8, Alte Pinakothek) and the triptych of Vienna (c.1504, Academy of Fine Arts) signal a return to the expedient compositions and techniques that typify his earlier phase: figures arranged in horizontal bands cover the surface of the painting, and the visionary nature of the subject likewise connects them with the first triptychs. Other works, such as the *St Anthony* (1510, Museu del Prado, Madrid), *The Prodigal Son* (c.1510

Boymans-Van Beuningen Museum, Rotterdam), and the *Epiphany* triptych (1510, Prado, Madrid) appear calmer and more disciplined, but the mood of tranquil harmony is deceptive: small details conceal the presence of demons, the underlying mood of pessimism evidently unchanged.

■ Bosch, Triptych of *the Last Judgment, Original Sin,* c.1504, Academy of Fine Arts, Vienna (top). The same scene appears in a wing of the *Hay Wain* triptych (c.1500, Museo del Prado, Madrid).

■ Bosch, Triptych of *the Last Judgment,* detail of *Hell,* c.1504, Academy of Fine Arts, Vienna.

■ Bosch, *The Prodigal Son*, c.1510, Boymans-Van Beuningen Museum, Rotterdam. The meticulously balanced composition, with its restricted range of colors, is an indication of the painter's interest in new forms and pictorial techniques.

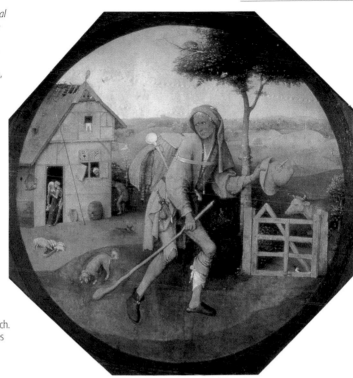

■ Bosch, *the Last Judgment*, 1506–8, Alte Pinakothek, Munich. The demonic creatures represent Bosch's indulgence in a last flight of fantasy.

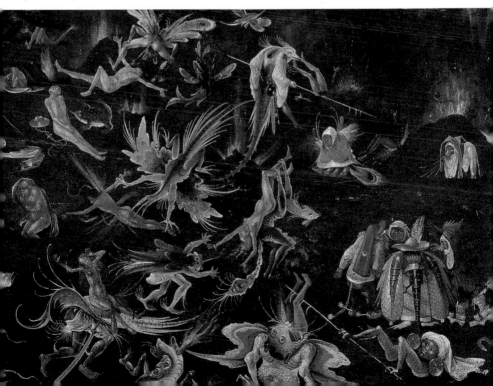

Adoration of the Magi

The *Epiphany* triptych, last of Bosch's great triptychs, from around 1510, was forfeited by the duke of Alba in 1568 to Jan Casembort, secretary to the count of Egmont; listed among the works sent in 1574 by Philip II to the Escorial, it is today in the Prado, Madrid.

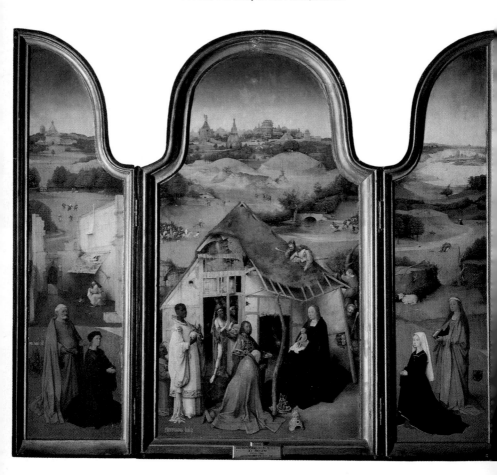

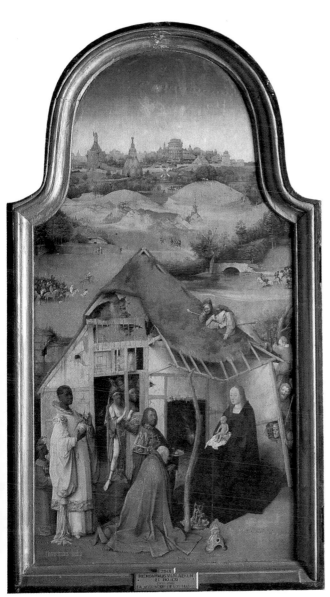

■ The *Adoration of the Magi*, previously the subject of an earlier painting, occupies the whole central panel: outside a flimsy cabin sits the imposing figure of the Virgin, in the act of presenting the child to the foreign kings, sumptuously clothed. Obscure characters in the scene include a figure wrapped in a red cloak, with a crown and an anklet band: this may represent the Antichrist, Herod, or a personification of heresy.

■ Geertgen tot Sint Jans, *Adoration of the Magi*, c.1485, Rijksmuseum, Amsterdam. The work of the primitive Dutch painter, active mainly in Haarlem, shows a structure similar to that of Bosch: the latter's figures, however, are characterized by a new dimension of monumentality which, like the depth of the background landscape, reveals the influence of Italian painting.

The Epiphany triptych

On the inner wings of the *Epiphany* triptych, left and right, appear St Peter and St Agnes with the donors: on the back Gregory the Great celebrates Mass before the apparition of Christ, surrounded by scenes of the passion.

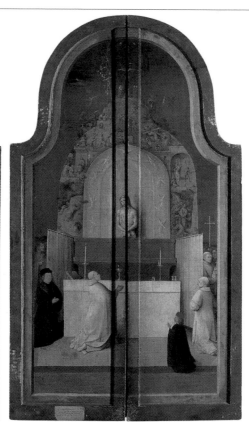

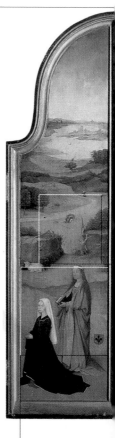

■ Seated on a wicker basket, protected by a flimsy roof, the figure of a man dries some clothing before the heat of the fire: this is an intimate image of Joseph, busy warming the swaddling clothes of the baby Jesus.

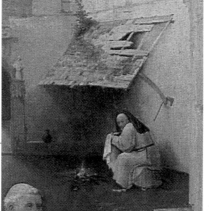

■ The broad stretch of landscape in the background is bathed in warm, golden light which fades gradually to the hazy blue of the horizon: this new expansiveness is typical of the mature work of Bosch.

■ The scene is only calm and tranquil in appearance: there are subtle signs of evil scattered around the entire triptych. In this instance, a bear and a wolf are attacking some wayfarers, alluding to the unpredictable obstacles that await humanity in the course of life's journey. The theme is similarly treated in the left-hand panel of the *Garden of Earthly Delights* (1503–4, Museo del Prado, Madrid), where the atmosphere of paradisal enchantment is almost imperceptibly interrupted by a lion busy dismembering a deer.

■ The kneeling woman has been identified as Agnes Bosshyuse, indicated by the family coat of arms and the presence of the patron saint Agnes, whose attribute, the lamb, appears in the background. The Bosshyuse and Bronckhorst families, the latter identified by the coat of arms in the left panel, commissioned the painting, perhaps for the cathedral of 's Hertogenbosch.

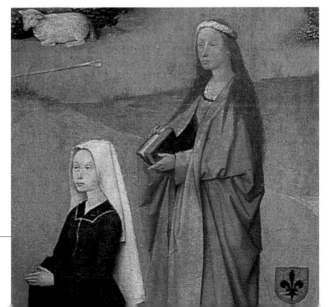

125

Reflections on human destiny

■ Bosch, *Child at Play*, reverse of the *Ascent to Calvary*, 1490–1500, Kunsthistorisches Museum, Vienna (right). The child may be intended to represent the infant Jesus.

T̲he entire artistic production of Bosch, consisting of some 70 paintings, is centered upon a few fundamental themes. The principal protagonist is mankind, vividly portrayed as he progresses on his sad journey through temptation, corruption, and sin. The numerous representations of the Last Judgment and of Hell emphasize the inevitable fate of the countless numbers destined for eternal torment. Yet the artist's unrelenting mood of pessimism does occasionally lift to allow a glimpse of salvation, as, for example, in the pictures of hermits and in episodes relating to Christ's passion: the examples offered by the contemplative life of the saints and the meditation on Christ's sacrifice are presented as the sole means of escaping the evil that pervades every aspect of life. Only seen in this light does the teeming, phantasmagorical universe of Bosch, with its infinity of esoteric forms, assume definitive meaning.

■ Bosch, *Hay Wain Triptych*, outer wings with *The Journey of Life*, c.1500, Museo del Prado, Madrid. The theme of the pilgrimage through sin is repeated in *The Prodigal Son* (c.1510, Boymans-Van Beuningen Museum, Rotterdam).

■ Bosch, The *Ascent to Heaven*, detail, 1500–4, Palazzo Ducale, Venice.

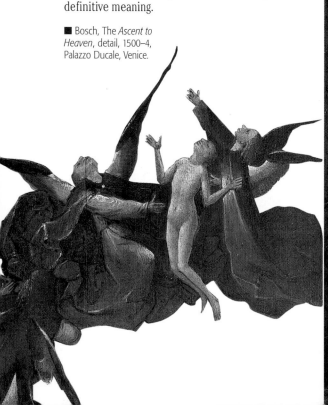

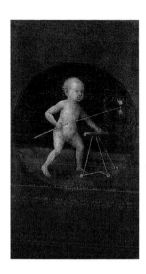

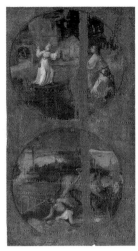

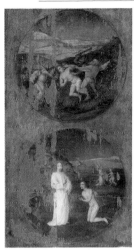

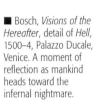

■ Above, Bosch, triptych of *The Flood,* c.1500, outer wings, right and left respectively, Boymans-Van Beuningen Museum, Rotterdam.

■ Bosch, *Visions of the Hereafter*, detail of *Hell*, 1500–4, Palazzo Ducale, Venice. A moment of reflection as mankind heads toward the infernal nightmare.

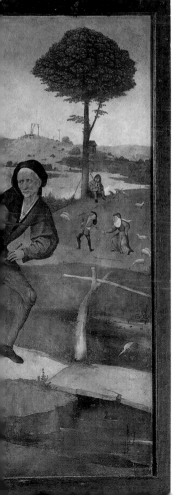

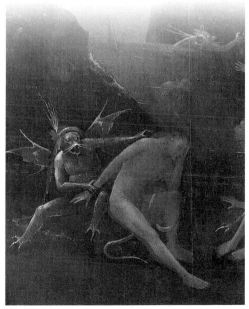

127

Bosch and engraving

■ Hieronymus Cock, *The Beleaguered Elephant,* c.1575. a precious graphic record of a now-vanished painting by Bosch.

Around the middle of the 16th century, several decades after his death in 1516, Bosch's fantastic and extravagant motifs were rediscovered, adapted, and perpetuated by the art of engraving. Prints based on Bosch's creations were circulated throughout Europe, initially by Hieronymus Cock, an accomplished engraver and printer from Antwerp who left a legacy, among other things, of valuable images derived from vanished originals. The success of the prints based on Bosch's visions was so immediate as to stimulate the production of imitations and copies of every kind, including counterfeits and fakes. The important fact, however, was that even these images, at least in part, were conceived in the spirit of Bosch, complete with outlandish monsters and apparitions. In particular demand were the proverbs, and all manner of scenes that had a moral content and recognizable folk themes. Even Peter Bruegel the Elder used Bosch's name to "sign" engravings based on the latter's designs, aware of the commercial advantage of linking his name with that of his predecessor.

■ Anonymous, *Fantastic Figures,* c.1570. The print makes a specific reference to Bosch, but the engraving is probably derived from Bruegel and only indirectly inspired by Bosch's art.

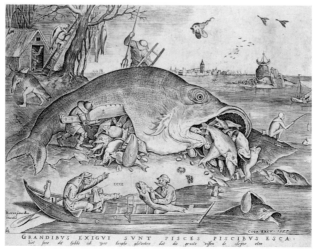

GRANDIBVS EXIGVI SVNT PISCES PISCIBVS ESCA.

■ Peter van der Heyden, *The Big Fish Eats the Smaller Fishes,* 1557. The print, which illustrates a popular proverb, is based on a drawing by Bruegel, but is likewise partly indebted to the ideas of Bosch.

128

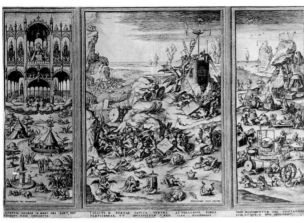

■ Anonymous Flemish painter, *Last Judgment*, c.1575. It is possible that the engraving illustrates a lost altarpiece: certain details are extremely interesting, but the celestial architecture of the left-hand panel bears no resemblance to any of Bosch's work.

■ Peter van der Heyden, *Festivities of Shrove Tuesday*, 1567. The engraving makes reference to the traditional theme of a group of people coming together to eat and enjoy themselves by making music. The engraver, who acknowledged his debt to Bosch, actually pays tribute to several artists: only the old woman shaving the man on the right finds a parallel in a drawing by Bosch.

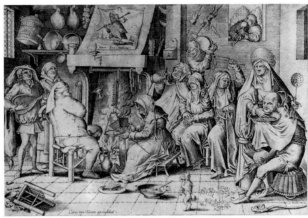

■ Anonymous Flemish painter, *The Tree Man*, early 17th century. The quite exceptional inventiveness of Bosch, as seen in the *Musicians' Hell* (see pp. 50–51), is here transformed into a casual and amusing sideshow.

The greatest interpreter: Peter Bruegel the Elder

■ Bosch, *Beggars and Cripples*, drawing no.154, Albertina, Vienna. The "Confraternity of Beggars", as it was then entitled, reflects the reality of the age.

Many imitators derived subjects and images from Bosch's work without touching upon the essence: it was only one artist, Peter Bruegel (c.1525–69) who probed the strange world of Bosch with true intelligence and understanding, making it the departure point for his own incomparably original work. Possibly a native of Breda, after training in Antwerp and travelling to Italy, Bruegel came into contact with the engraver and publisher Hieronymus Cock in 1554. It may have been this fervent admirer of Bosch who first stimulated Bruegel's interest. The visionary imagination of the Brabant painter attracted Bruegel and spurred him to delve more deeply into his precursor's iconographic sources, directing him in particular toward the worlds of traditional and popular culture. But the quest for realism that was typical of the Renaissance persuaded Bruegel to concentrate on aspects of everyday life and nature: for the nightmarish visions of Bosch he substituted his uniquely ironic conception of the human comedy, set in village squares and country landscapes.

■ Peter Bruegel the Elder, *The Cripples*, 1568, Musée du Louvre, Paris. The world of folklore was an iconographical source for Bosch and Bruegel.

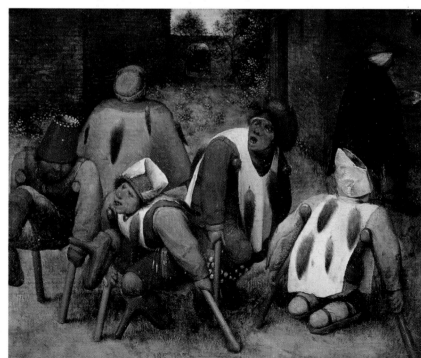

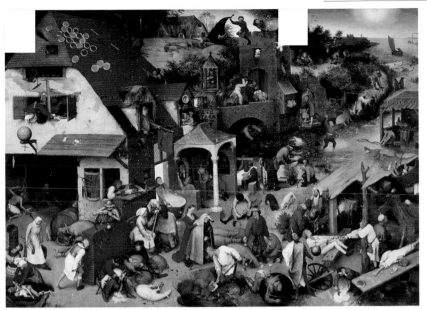

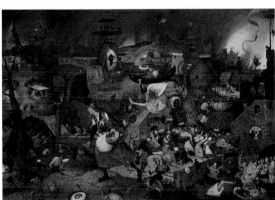

■ Peter Bruegel the Elder, *Netherlandish Proverbs,* 1559, Staatliche Museum, Berlin. The lively scene of urban life conceals the representation of more than a hundred proverbs: he inherited from Bosch a taste for contrasting, pure colors and the detailed composition of figures throughout the work.

■ Peter Bruegel the Elder, *Mad Meg,* 1562, Mayer van den Bergh Museum, Antwerp. A medieval witch embodies human greed.

■ Peter Bruegel the Elder, *The Fall of the Rebel Angels,* 1562, Musées des Beaux-Arts, Brussels. The monstrous devils are clearly derived from Bosch.

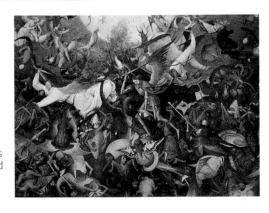

BACKGROUND

Bosch and modern culture:
the unconscious and the surreal

Twentieth-century criticism has sought to explain the enigmatic world of Bosch in terms of the psychoanalytical theories of Freud: thus only through the release of the forces of the unconscious would it be possible to reproduce those nightmarish visions of five centuries ago. The fantastic, spectral universe of Bosch's imagination is effectively comparable to the consequences of the automatism described by André Breton in his first manifesto on Surrealism (1924). Breton himself defined Bosch as "the integral visionary" and conferred upon him the role of a historical model: the boundless poetry of his imagination anticipated "the painters of the unconscious". Moreover, the fascination with alchemy was similarly a bridge that linked Bosch with the exponents of the late avant-garde.

■ Miró, *The Staircase of Flight*, 1940, Museum of Modern Art, New York.

■ Miró, *The Morning Star*, Miró Foundation, Barcelona. Miró's cryptic symbols produce effects similar to those obtained by Bosch.

■ Max Ernst, *Inside View: the Egg*, 1929, Private Collection, Paris. There are frequent allusions in Ernst's work to the language of alchemy: the cavity of the egg is in fact a symbol for the crucible.

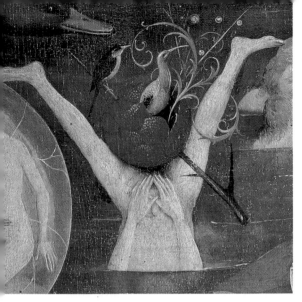

■ The enigmatic reversed figure in André Masson's *The Androgynous Hourglass* shows similarities with Bosch's vision, reproduced above.

■ Victor Brauner, *The Philosopher's Stone*, 1940, Private Collection. The work of the Romanian artist (1903–6) touches upon the world of exoticism and alchemy, creating a strangely unsettled atmosphere.

■ Bosch, *The Garden of Earthly Delights*, detail of the *Musicians' Hell,* 1503–4, Museo del Prado, Madrid. Psychoanalysts recognize in Bosch dream symbols and erotic metaphors: here, too, the key may be sexual symbolism.

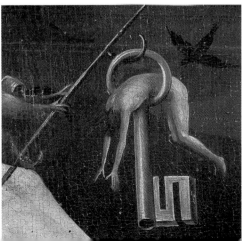

133

Note

The places listed in this section refer to the current location of Bosch's works. Where more than one work is housed in the same place, they are listed in chronological order.

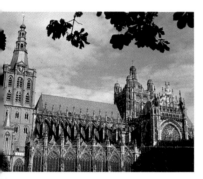

■ The Gothic cathedral of 's Hertogenbosch, Bosch's native city.

■ Philadelphia, Museum of Art.

■ London, National Gallery.

Berlin, Gemäldegalerie,
St John on Patmos, pp. 53, 75, 78, 79, 81.

Berlin, Kupferstichkabinett,
This Field Has Eyes, This Wood Has Ears, p. 19.

Bruges, Groeninge Museum,
The Last Judgment triptych, p. 97.

Brussels, Musées Royaux des Beaux-Arts,
Crucifixion, pp. 8, 26.

Cologne, Wallraf-Richartz Museum,
Adoration of the Shepherds, p. 105.

Frankfurt, Städelsches Kunstinstitut,
Ecce Homo, pp. 38–39; *Christ Before Pilate*, p. 63.

Ghent, Musée des Beaux-Arts,
The Ascent to Calvary, pp. 64–65; *St Jerome at Prayer*, pp. 82-83.

Lisbon, Museu Nacional de Arte Antiga,
The Temptation of St Anthony, pp. 27, 34, 52, 53, 92, 109, 112–13, 114–15, 116–17, 118, 119.

London, National Gallery,
Crowning with Thorns, pp. 106–7.

Madrid, Escorial, Monastero di San Lorenzo,
Crowning with Thorns, pp. 84, 104.

Madrid, Palazzo Reale,
Ascent to Calvary, p. 26.

Madrid, Museo Lazaro Galdiano,
St John the Baptist in Meditation, pp. 76-77.

Madrid, Museo del Prado,
The Seven Deadly Sins, pp. 6–7, 15, 21, 43, 91, 97, 103; *The Cure of Folly*, pp. 16–17; *Hay Wain triptych*, pp. 19, 30–31, 32–33, 34, 35, 69, 91, 109, 126; *The Garden of Earthly Delights triptych*, pp. 14, 24–25, 27, 29, 34, 35, 46–47, 48–49, 50–51, 54, 75, 93, 108, 133; *The Epiphany triptych*, pp. 69, 78, 122–23, 124–25; *Temptation of St Anthony*, pp. 55, 88–89, 110–11.

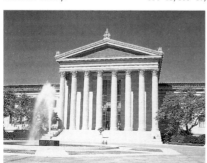

■ Vienna,
Kunthistorisches
Museum.

■ Madrid, Museo
del Prado.

Munich, Alte Pinakothek,
The Last Judgment,
p. 120.

Oxford, Ashmolean Museum,
*Drawing with Sketches of
Animals and Monsters,* p. 54;
Drawings of Animals, p. 55.

Paris, Musée du Louvre,
The Ship of Fools, pp. 18, 41;
The Ship of Fools (preparatory
drawing), p. 40;
Death of the Miser
(preparatory drawing), p. 43.

Philadelphia, Museum of Art,
The Epiphany, p. 9.

**Rotterdam, Boymans-Van
Beuningen Museum,**
The Marriage at Cana, p. 15;
The Flood triptych, pp. 10, 45, 127;
St Christopher, p. 80;
The Prodigal Son, p. 120.

**Saint Germain-en-Laye,
Musée Municipal,**
The Conjurer, pp. 22–23.

Venice, Palazzo Ducale,
Altarpiece of the Hermits, pp. 55,
56–57, 67, 85;
The Crucifixion of St Julia,
pp. 66, 67, 68–69;
Visions of the Hereafter,
pp. 86–87, 108, 126, 127, 134–135.

Vienna, Academy of Fine Arts,
The Last Judgment triptych, pp.
36, 45, 53, 98–99, 108, 120.

Vienna, Albertina,
Beggars and Cripples, p. 130.

**Vienna, Kunsthistorisches
Museum,**
Ascent to Calvary, pp. 21, 117, 126.

**Yale, University
Art Gallery,**
Allegory of the Pleasures, p. 44.

**Washington, National
Gallery of Art,**
Death of the Miser, pp. 42–43.

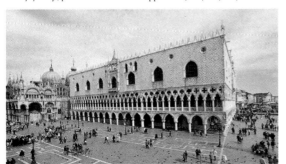

■ Venice,
Palazzo Ducale.

Note

All the names mentioned here are artists, intellectuals, politicians, and businessmen who had some connection with Bosch, as well as painters, sculptors, and architects who were contemporaries or active in the same places as Bosch.

■ Albrecht Altdorfer, *Holy Family at the Fountain*, 1510, Gemäldegalerie, Berlin.

■ Hans Burgkmair the Elder, *Deposition of the Cross*, 1519, Thyssen Collection, Madrid.

Aken, Anthonis van, painter, Bosch's father, p. 8.

Aken, Jan van, painter, Bosch's paternal grandfather, who left to his sons a thriving workshop where the young Hieronymus had his first lessons, p. 8.

Altdorfer, Albrecht (1480–Ratisbon c.1538), painter, a representative of the "Danube School", famous for his extraordinary landscapes and architectural features which tended to become the central subject, p. 72.

Aspertini, Amico (Bologna 1474–1552), singularly inventive painter and sculptor, whose strange forms and facial characterizations reveal a familiarity with the art of northern Europe, p. 72.

Bellini, Giovanni (Venice c.1432—1516), son of Jacopo, brother of Gentile, and brother-in-law of Andrea Mantegna, he was the official painter of the Serenissima from 1483, who during sixty years of painting absorbed the basics of art from great contemporaries, such as Piero della Francesca and Antonello da Messina. He developed his own prodigious style, characterized by the progressive liberation of color from design, associated with the new trend in Venetian painting of Titian and Giorgione, pp. 104, 105.

Brant, Sebastian, Dutch writer, university lecturer, and author of the famous book *The Ship of Fools* pp. 26, 40.

Bruegel, Peter, the Elder (Breda c.1528–Brussels 1569), Flemish painter and illustrious head of a family of gifted artists who, after a journey to Italy, worked in Antwerp, then in Amsterdam, and finally in Brussels. He was inspired by Bosch and by the earlier Flemish painters of the 15th century, and as a result of his interest in popular and folk subjects he came to be

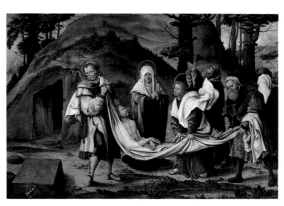

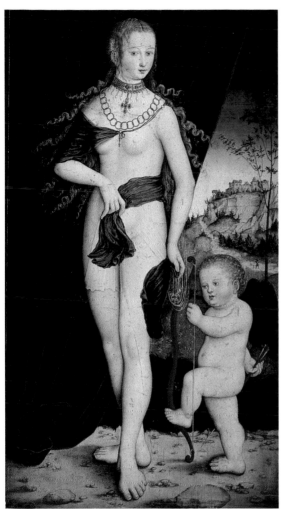

Dürer, Albrecht (Nuremburg 1471–1528), German painter, designer, and theorist, among the greatest artists of all time. Deeply affected by humanism, he was a scholar and admirer of the Italian Renaissance, and eventually influenced many artists, including Italians. It is not certain whether he actually met Bosch in person, but it is undeniable that either he had seen his works or that Bosch was familiar with Dürer's; both expressed the moral and artistic tensions of their time, and would seem on several occasions to have exchanged ideas, pp. 11, 40, 62, 71, 72, 73, 74, 75, 78, 83, 85, 92, 118.

Erasmus of Rotterdam (1466–1536), Dutch humanist who looked forward to an internal reform of Catholicism, anticipating in some respects the thinking of Luther. His teaching had much in common with the ideas and images of Bosch, notably in denouncing clerical vices, and

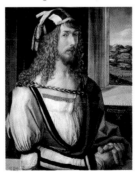

■ Albrecht Dürer, *Self-portrait with Landscape*, 1498, Museo del Prado, Madrid.

nicknamed "Peasant Bruegel", pp. 11, 18, 23, 128, 129, 130.

Burgkmair, Hans, the Elder (Augsburg 1471–1531), German painter and wood-engraver, who was, with Dürer, one of the first German masters receptive to the artistic ideas of the Italian Renaissance pp. 36, 37, 80.

Carpaccio, Vittore (Venice c.1460–1526), painter, linked with Venetian humanism and noted mainly for his cycles of

paintings for the Venetian schools of Sant' Orsola, San Giorgio degli Albanesi, and Santo Spirito, p. 72.

Cranach, Lucas, the Elder (Kronach 1472–Weimar 1553), renowned painter and engraver, he was the head of an extremely active workshop and his profound innovations in structure and composition appeared mainly in his religious paintings, pp. 72, 119.

■ Geertgen tot Sint Jans, *Madonna in Glory*, c.1480 Boymans Van-Beuningen Museum, Rotterdam.

Grimani, celebrated Venetian family, whose members included three doges between the 13th and 16th centuries, and also the famous Cardinal Domenico, a keen art collector, pp. 44, 72.

Grünewald, Mathias, real name Mathis Gothhardt Neithardt Grünewald (Würzburg c.1480–Halle 1528), great German painter who lived in Mainz in the service of Archbishop Albert of Brandenburg, pp. 20, 62, 90, 118.

Jacopo da Varagine or da Varazze (? Varazze c.1228–Genoa 1298), Domenican who wrote the *Golden Legend*, a collection of the lives of the saints in Latin, pp. 26, 110.

Kempis, Thomas à, real name Thomas Hemerken (c.1379–1471), Augustinian, German mystic and probable author of the *Imitatio Christi*, p. 20.

Leonardo da Vinci (Vinci, Florence 1452–Amboise 1519), painter, sculptor, architect, engineer, and writer, Leonardo conceived science as a complement to artistic endeavor;

urging the need for moral revival, pp. 18, 90.

Geertgen tot Sint Jans, called Gerrit of Haarlem (Leyden c.1465–Haarlem c.1495), painter regarded as an important founder of Netherlandish art, whose work was concentrated exclusively upon religious subjects, pp. 13, 84, 123.

Gioacchino da Fiore (Celico c.1130–San Giovanni in Fiore c.1202), churchman and mystic, Cistercian preacher, who founded the congregation of the Florensi, p. 80.

Giorgione, known as Zorzi (or Giorgio) da Castelfranco (Castelfranco, Veneto c.1477–Venice 1510), painter who brought great innovations to Venetian painting; some of his works are marked by intense

personal introspection, to the point of deforming the physical attributes of some characters – reminiscent of Bosch, pp. 62, 70, 71, 77, 79.

Goyaerts, Aleyt van der Meervenne, daughter in a wealthy aristocratic family who married Bosch in about 1480, p. 14.

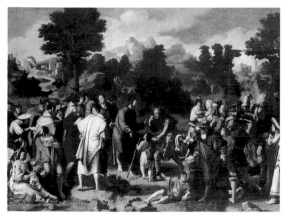

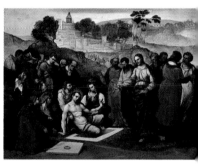

■ Lucas van Leyden, *The Blind Man of Jericho*, 1531, Hermitage, St Petersburg.

■ Lodovico Mazzolino, *The Raising of Lazarus*, c 1527 Pinacoteca di Brera, Milan.

a contemporary of Bosch, he may have met him in Venice or Milan at the end of the 15th century, pp. 58, 60, 61, 65, 118.

Lotto, Lorenzo (Venice c. 1480 –Loreto 1556), painter, long active in the Marches, in Rome, and in Bergamo; a sensitive artist who led a restless, wandering life, and received little mention from older critics but who has been revalued in the present century and compared with the great masters of the first half of the 16th century; details of his works show the influence of northern artists, pp. 70, 71, 79, 83.

Lucas van Leyden (Leyden 1494–1533), Dutch painter who as a young man was active in engraving, being inspired mainly by the work of Dürer, pp.17, 28, 29, 108, 110.

Margaret of Austria (1480–1530), daughter of Maximilian of Austria and regent of the Low Countries, a post she held until her death; she may have been a client of Bosch, p. 44.

Mazzolino, Lodovico (Ferrara c.1480–c.1530), painter who from his youth was active at the Este court; he was trained in the Ferrara tradition, his works show northern influences from Dürer to Schongauer, and recall the agitated, restless rhythms of Bosch's painting, pp. 71, 72.

Memling, Hans (Memlingen c.1435—Bruges, 1494), painter, pupil in Brussels of Rogier van der Weyden who then established himself in Bruges, where he soon became popular and wealthy. He was a religious painter, genre scenes and, above all, portraits,

synthesizing the stylistic influences of the great Flemish artists such as Van Eyck and Van der Weyden, and the Italians, pp. 13, 72.

Metsys, Quinten (Louvain 1466–Antwerp 1530), Flemish painter, regarded as the initiator of the so-called "Antwerp school", who painted large altarpieces, characterized by an original interest, on the one hand, in expansive landscapes and, on the other, by an expressive, psychological delineation of character, particularly evident in his famous portraits and genre paintings. He had a considerable

■ Mathias Grünewald, *Dead Christ*, 1523–25, Collegiate Church, Aschaffenburg.

■ Hans Memling, *Reliquary of St Ursula*, before 1489, Memlingmuseum, Bruges.

of Castile thanks to his marriage with Joan the Mad: he was perhaps one of Bosch's clients, p. 44

Ruysbroeck, Jan van (1293–1381), Flemish mystic who had great influence as a a writer, a follower of the *Devotio Moderna*, pp. 80, 87

Savoldo, Giovan Gerolamo (Brescia c.1480–Venice 1550), painter, exponent of the Lombard school together with Moretto of Brescia and Romanino, p. 111.

influence on artists of later generations, not only in his homeland, pp. 19, 58, 62, 63, 90, 94, 95, 100, 103.

Paracelsus, real name Theophrastus Bombastus von Hohenheim (1493–1541), influential, though flawed alchemist, physician, naturalist, and philosopher, p. 92.

Patinir, Joachim (Bouvignes c.1480—Antwerp 1524), Flemish painter, active in Antwerp, he was a friend and collaborator of great artists such as Quinten Metsys and Joon van Cleve and was considered among the initiators of Flemish landscape painting which developed during the 16th century, pp. 10, 72, 78, 81, 94.

Philip I the Handsome (1478–1506), son of the Habsburg emperor Maximilian I and Mary of Burgundy, who inherited Flanders from his mother and became king

Schongauer, Martin (Colmar 1453–Breisach 1491), German painter and engraver who influenced the figurative culture of his time. His prints were circulated throughout Europe and were imitated in many workshops, pp. 71, 72.

Van Eyck, Jan (? Maastricht c.1390–Bruges, 1441), painter who, according to some, initiated with his painting the great school of Flemish Renaissance art. His

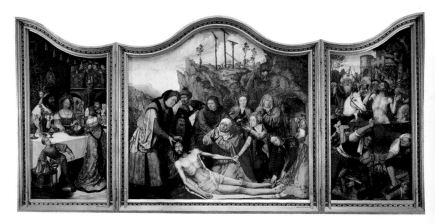

■ Martin Schongauer, *Madonna in Rose Garden,*1473, Colmar, St Martin, Colmar.

■ Jan Van Eyck, *Man with Red Turban*, 1433, National Gallery, London

influence was considerable, not only in his homeland but also in Italy, especially on Antonello da Messina, in the Iberian peninsula and in Germany, pp. 12–13.

Van Scorel, Jan (Schoorl 1495–Utrecht, 1562), Dutch painter who travelled in Germany, where he met Dürer, and in Italy, where he became curator of the Belvedere in Rome and worked in the Vatican. The works of this period reveal Venetian and German influences; back in Holland he represented early Mannerism, which was emulated for a whole generation, p. 100.

Weyden, Rogier van der (Tournai c.1400–Brussels 1464), Flemish painter, almost certainly a pupil of Robert Campin, who became official painter to the court of Brussels from 1485; his extraordinary portraits, devoted mainly to dignitaries of the Burgundian court, had great influence upon contemporary artists, including Italians, pp. 12–13, 29, 96.

■ Quinten Metsys, *Triptych of the Guild of Cabinet-makers with the Sorrow of Christ,* 1509, Musées Royaux des Beaux-Arts, Brussels.

■ Rogier van der Weyden, *Madonna with Child Enthroned,* 1432–35, Thyssen Collection, Madrid.

A DK PUBLISHING BOOK
Visit us on the World Wide Web at http://www.dk.com

TRANSLATOR
John Gilbert

DESIGN ASSISTANCE
Joanne Mitchell

MANAGING EDITOR
Anna Kruger

Series of monographs
edited by Stefano Peccatori and Stefano Zuffi

Text by Alessia Devitini Dufour

PICTURE SOURCES
Archivio Electa
Elemond Editori Associati wishes to thank all those museums and
photographic libraries who have kindly supplied pictures, and would be pleased
to hear from copyright holders in the event of uncredited picture sources.

Project created in conjunction with
La Biblioteca editrice s.r.l., Milan

First published in the United States in 1999 by DK Publishing Inc.
95 Madison Avenue, New York, New York 10016

ISBN 0-7894-4139-X

Library of Congress Catalog Card Number: 98-86748

First published in Great Britain in 1999
by Dorling Kindersley Limited,
9 Henrietta Street, London WC2E 8PS

A CIP catalogue record of this book is available from the British Library.

ISBN 0751307254

2 4 6 8 10 9 7 5 3 1

Printed by Elemond s.p.a. at Martellago (Venice)